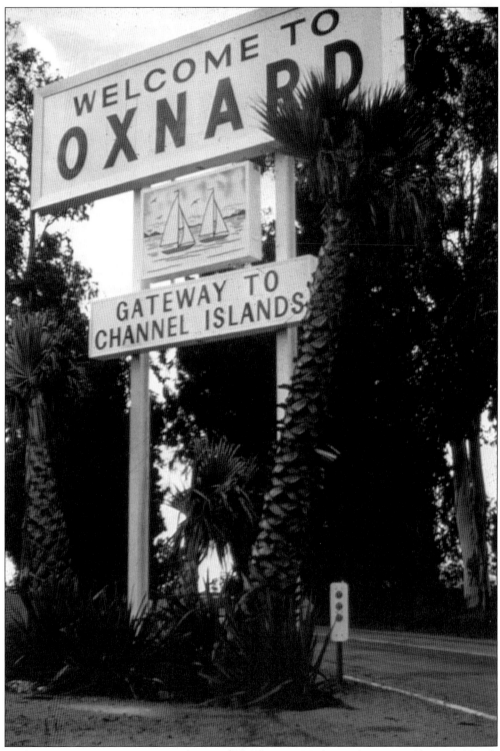

In the 1960s, motorists entering the Oxnard Area via Highway One near Channel Islands Boulevard were greeted with this sign.

IMAGES of America
OXNARD
1941–2004

Jeffrey Wayne Maulhardt

Copyright © 2005 by Jeffrey Wayne Maulhardt.
ISBN 0-7385-2953-2

Published by Arcadia Publishing
Charleston SC, Chicago IL, Portsmouth NH, San Francisco CA

Printed in Great Britain

Library of Congress Catalog Card Number: 2004116964

For all general information contact Arcadia Publishing at:
Telephone 843-853-2070
Fax 843-853-0044
E-mail sales@arcadiapublishing.com
For customer service and orders:
Toll-Free 1-888-313-2665

Visit us on the internet at http://www.arcadiapublishing.com

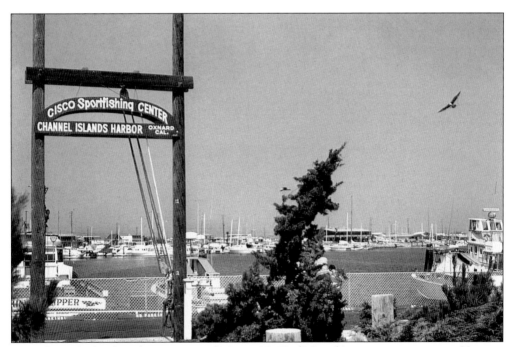

The Channel Island Harbor was one of Martin V. "Bud" Smith's many enterprises in Ventura County. Construction of the harbor began in 1967. This 1970s photo shows a view of the jetty and Channel Island Harbor.

Contents

Acknowledgments		6
Introduction		7
1.	The Harbor	9
2.	The Boulevard	19
3.	A Street and Beyond	29
4.	Oxnard Grows	63
5.	People	71
6.	Snow in Oxnard	97
7.	Sports	109
8.	The Centennial	119

Acknowledgments

Tracking down pictures, names, and stories is not an easy task. In many cases, I was successful, but in others, I ran out of luck and/or time. Selection was another challenge. Sometimes pictures weren't available, and sometimes pictures didn't fit a theme or format. I know there are many pictures that could have or should have been included. My hope is that this book will inspire people to begin to share their photos so that more of this rich history can be documented. Let this be one of many small steps in a giant effort to record some more history of the area.

Once again, I'd like to thank my regular "staff of help" in providing me with some of the pictures that help make this volume the book I wanted it to be; Brenda Crispen and the staff at the Oxnard Public Library who have again generously provided me with several pictures that were provided to me on a prompt and frequent basis; My friends Eric Daily and Gary Blum, who, besides being on the lookout for pictures and information I could use in my publication, allowed me to copy and borrow all that I needed; Frank Naumann, for sharing his Oxnard memorabilia with another Oxnard memorabiliac; Charles Johnson, the invaluable librarian for the Ventura County Museum of History and Art, who has also put me on his list of Oxnard-interested material; Bob Valles for sharing his pictures and time; Bob Pfeiler for allowing me to scan many of the pictures he took himself, which have documented much of Oxnard's midyears; Yolanda Pina for sharing the Carty pictures and ghost stories from the Cary house (I hope my great, great grandmother will allow your family to sleep peacefully!); Jeanne Maulhardt Sweeney; Vickie Smith Pozzi; Richard Arias for the Cowboy connection; Paul Ronin for the Sunset picture; Hidania Novoa for the Sunset support; Gil Ramirez for the baseball support; Daryl Samuel for searching for the pic; Spencer Garrett for the Snodgrass pictures; Richard and Ruth Maulhardt for continued support and generosity; Jerry Willard Sr. and Jr. for the baseball stuff; and thanks to Mom for making a few calls for me.

Thanks to Craig Maulhardt for many of the sports pictures; Tim Maulhardt for the phone calls and everything else; Sam Camacho for tracking down his dad's pictures and articles; Mary Sargent for the Donlon pic; David Weigel; Ed Weigel for the World War II pictures and information and for giving me a tour of Oxnard with the stories to complement the occasion; Donna Matson for donating her cousin Carroll Lorbeer's documents to my research projects; Bobbi Eck for the Kennedy pictures; my former student Daniel Garcia for sharing the boxing pics; R.J. Frank student Maya Smith for all her help; good friend and gopher Marcel Brickey; and Mayor Manuel Lopez for his input on several pictures.

INTRODUCTION

With the introduction of agriculture, specifically the sugar beet, Oxnard became a town of 2,000 at the turn of the century. By the year 1940, the population was at 8,519 and the city limits covered 2.87 square miles. The next 60 years saw the population grow 500 percent and top 180,000 residents by the time Oxnard reached its centennial year, 2003. The city was incorporated with the introduction of sugar beets but by a hundred years' end, the beet was gone and the berry was here. By 2003, Oxnard planted 10,349 acres to strawberries.

A change in population occurred a few short months after the Japanese bombed the naval base at Pearl Harbor, Hawaii, in December 1941. By February 1942, 343 Japanese residents from Ventura County, many from Oxnard, were forced to relocate to isolated camps throughout the United States. The Japanese farmer had grown to great importance in agricultural community. Approximately 10 percent of the land in Ventura County, or 1,200 acres, were farmed by Japanese. In addition, several crops were grown exclusively by Japanese farmers, including cabbage, cauliflower, celery, cucumbers, and bell peppers.

The installation of the navy base in Hueneme, the third largest in the United States, added substantially to the population. The U.S. government committed to a rearmament program that called for the production of 50,000 airplanes per year and 53 million maritime pieces, i.e. ships, boats, and submarines. All able-bodied Americans were pulled from the farms and relocated to factories and military. To make up for the shortage of labor, the government came up with a temporary solution to the problem, the Bracero program. The Bracero treaty was signed in August 4, 1942. The program called for the American government to protect the Mexican Nationals in accordance with Executive Order No. 8802. Mexicans workers entering the U.S. were guaranteed transportation, living expenses, and reparations as established in an article of the Mexican Federal Labor Law. Contracts were to be supplied in Spanish, and physicals were necessary for employment. The bracero work force totaled up to 5 million workers over the next 22 years. The braceros helped the country produce the necessary foods and goods to support the war effort. However, the Bracero program was set up to aid in an emergency situation, and after the war ended in 1945, some of the local farm laborers found that they could not find work because of the collusive efforts of some farmers who preferred the less expensive bracero worker. Cesar Chavez was one of these workers who spoke up about the discrepancy.

Cesar Chavez was born near Yuma, Arizona, in 1927. His father, Librado Chavez, owned a farm and ran a general store. A series of droughts and the effects of the Great Depression caused the Chavez family to lose their farm in 1937. Chavez and his wife and six children joined the migrant workforce that totaled 300,000 workers from Oklahoma, Texas, Arizona and other hard-hit states. By 1938, the Chavez family began a succession of moves that took 11-year-old Cesar Chavez to approximately 65 schools over the next several years. One brief stop in 1939 was Oxnard, California. The Chavez family stayed in a storage building near the corner of Colonia Road and Garfield Street. Today, the site is commemorated with a plaque and is listed as Ventura County Point of Interest No. 9.

The end of WWII brought back the interned Japanese population. To the credit of these strong-willed families, many returned to become some Oxnard's most influential leaders. Nagao

Fujita grew up to be an effective lawyer; His wife, Lillie, became a respected educator. Nao Takasugi rose to the rank of California State Assemblyman. The Moriwaki family operated an electric motor business that is still in operation today.

The 1940s saw three new mayors: W. Roy Guyer (1938–1942), H.H. Eastwood (1942–1844), and Edwin L. Carty (1944–1950). It was during Carty's tenure that the city cleaned up the notorious "China Alley," the back alley between Oxnard Boulevard and A Street, between 7th and 9th Streets. During the worst of times, the area was host to opium dens, gambling, and prostitution. But it was one brothel in particular that propelled Oxnard into the national spotlight. *Time* magazine published an article about a lady who turned out to not be a lady. Lucy Hicks was a man that posed as a woman for 30 years while in Oxnard. "She" came from Kentucky under a cloud of mystery but was able to earn the respect of many of Oxnard's most prominent families. The Donlon family in particular hired Lucy to cook for the family for many years. By the Depression years of the 1930s, there were fewer opportunities for Lucy to make a legitimate living. Though it is not certain when Lucy became a madam/sir, by the 1940s she was working full time. When one of Lucy's "girls" contacted a social disease, the entire house was called in for a physical, including Lucy. By press time, the secret was out. Making the story even more interesting was the fact that in 1944, Lucy married a service man named Ruben Anderson. After a short trial in 1945, Lucy was expelled from Oxnard, and a few years later, Lucy died in Los Angeles.

Other changes occurred in the decade of 1940. Martin V. "Bud" Smith emerged as the most prominent developer of Ventura County. In the early 1940s, Smith was servicing jukeboxes in restaurants and bars between Los Angeles and Ventura Counties. One client fell behind on payments and Smith was offered a rickety-old drive-in stand in Oxnard as collateral. With the financial backing of farmer/real estate agent and future mayor of Oxnard, Ed Carty, Smith was able to remodel the old building into Oxnard's premier dining establishment, the Colonial House. After returning from the service in 1945, Smith's next investment was the Wagon Wheel Junction, which included a motel, restaurants, and other commercial properties. After building up the Wagon Wheel Junction, Smith and several partners purchased the old sugar beet factory site in 1959. He turned this property into an industrial park. Some of Bud Smith's other projects include the development of the Channel Islands Harbor with the construction of the Lobster Trap restaurant and a 300-room hotel, 120-apartment complex with boat slips; the Commercial and Farmers National Bank; in 1970, the original Esplanade opened land Smith owned and later sold; and the city's first high-rise buildings, a 15-story and next a 22-story skyscraper.

By the end of 1940, the population in Oxnard was up, from 8,519 at the start of the decade to 21,567 to close out the decade. Between 1950 and 1960, the numbers increased 78 percent. The 1950s saw many of the servicemen return to Oxnard. Cesar Chavez returned to Oxnard in 1958 on behalf of the Community Service Organization (CSO) with the intention of opening a chapter in Oxnard to assist the citrus laborers in the area. However, Chavez found that there was a bigger issue than what CSO was offering for the workers. Chavez was met with the issue of job denial of the local laborers at the expense of the braceros. Chavez took on the challenge of forcing employers to hire the local work force and through a series of strikes and picketing, and he ultimately won the locals their right to fair hiring. From this experience, Cesar Chavez began his life-changing work in organizing labor workers.

By the start of 1960, the population of Oxnard was at 40,000. From 1960 to 1970, the number was up 77 percent to 71,225. In 1980, the number grew to 111,700. By 1990, there were 147,528 residents. From 1970 to 1990, the population of Oxnard doubled. By the year 2000, the number was up to 172,600. Only two years later, Oxnard gained another 10,000 residents to total 182,027.

Oxnard's agricultural beginnings have given way to residential neighborhoods. While crops once reaped the benefits of the mild temperatures and year-round sunshine, these days people are the primary beneficiaries of the all that the city of Oxnard, California, has to offer.

One
THE HARBOR

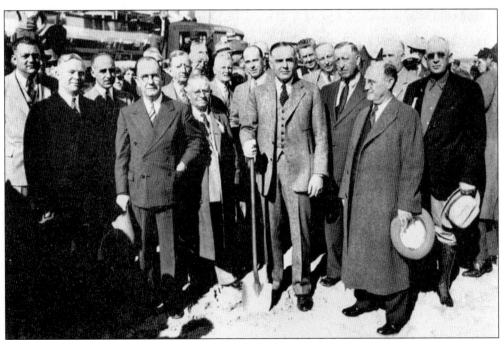

The Oxnard Harbor District was formed in 1937 after Richard Bard secured a bond for $1,750,000 to develop a modern port. In 1939, the groundbreaking ceremony was held. Pictured, from left to right, are (front row) Al Mehn, E.O. Green, Richard Bard (with shovel), Fred Aggen, and Al Dingman. Over Bard's right shoulder is former New York Giant Fred Snodgrass.

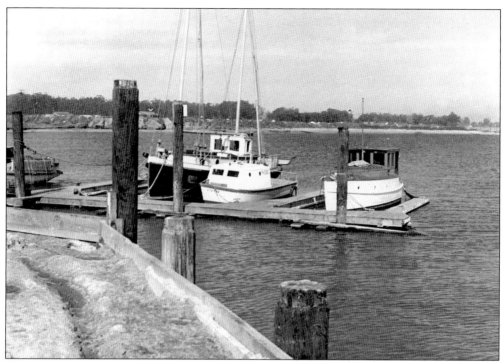

The Ventura County Boat Club was organized in 1937 and leased a portion of the harbor until the Navy took over the lease in 1942.

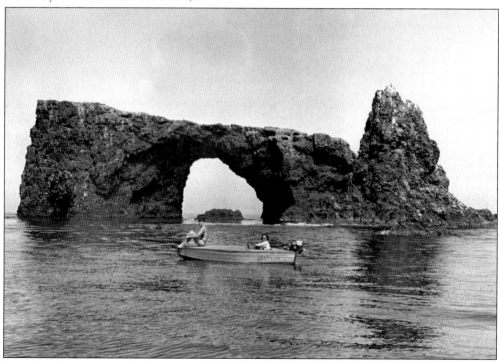

The islands were a popular destination of the boat club. This picture was taken in front of Arch Rock at Anacapa Island.

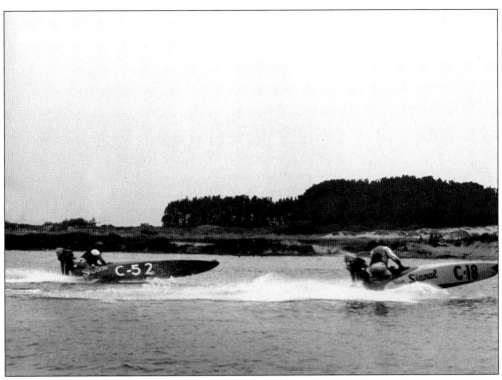

Races at McGrath Lake were common during the 1940s.

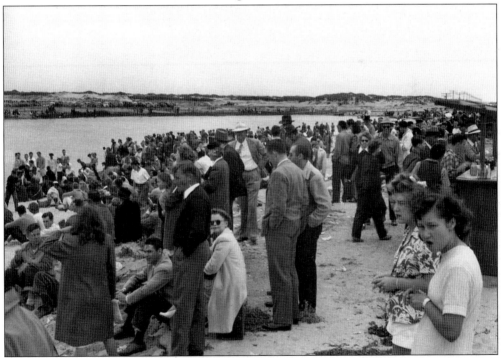

Spectators at McGrath beach often gathered to watch races and skiing exhibitions by Bob Pfeiler and other Ventura Boat Club members.

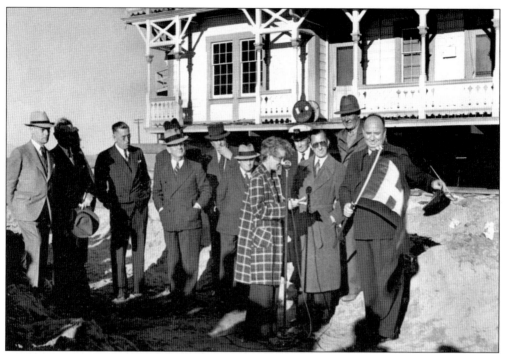

With the expansion of the harbor, the 65-year-old lighthouse would have to be moved or demolished. The structure was sold to the Oxnard Harbor District for $51.

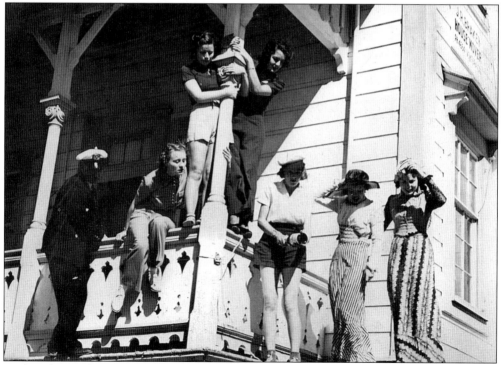

In this photo taken in February 1940, several of the wives of the Ventura County Boat Club pose for the cameras before the club's historic move across the harbor to its new location.

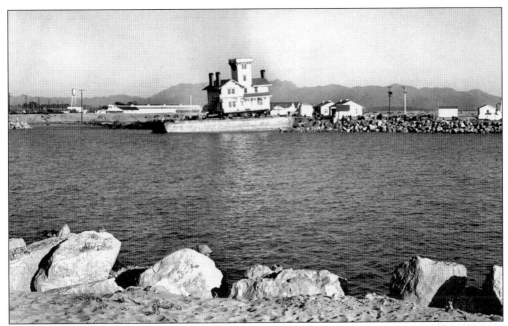

J.R. Brakey and his crew loaded the lighthouse onto a barge. Unfortunately for the hundreds of spectators, the 104-ton building caused the barge to sink farther than calculated, and the marooned lighthouse would have to wait for high tide to make its move to the Silver Strand beach side.

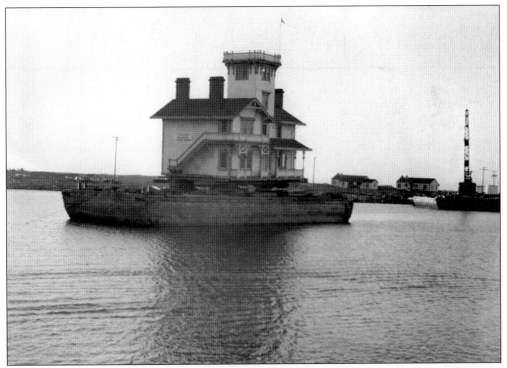

The lighthouse fell into disrepair at its new location, and less than three years after the move it was demolished by the Navy.

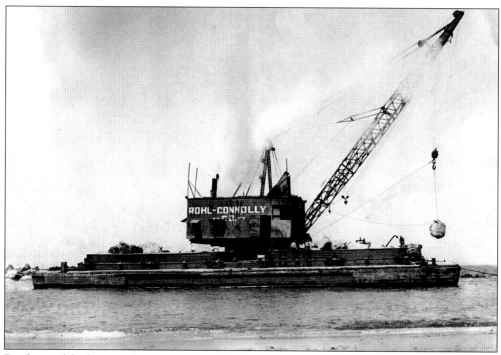
Dredging of the basin and construction of dock facilities began in January 1939. The rocks were brought in from Anacapa Island.

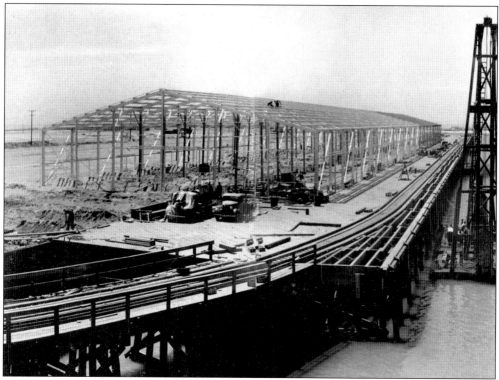
The dock and facilities were completed in 1940.

In early 1942, through condemnation, purchase, and lease of the land, the Navy took over the port, including the Bard family estate. Though their property was worth millions, the Bard family received a token of $150,000.

A total of 17,000 acres were added to the port expansion after the Navy took over.

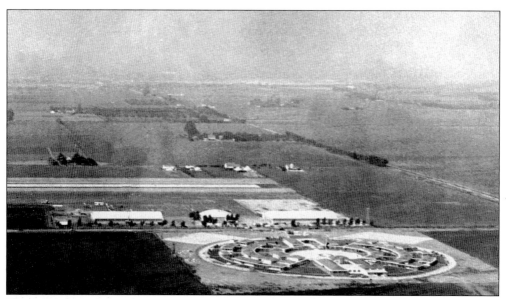

The 1,980-foot runway on 35 acres was built by the Works Progress Administration in 1935 and located west of Ventura Road and north of Fifth Street. The Mira Loma Flight Academy, built on the west side of Fifth Street, was opened in June 1940. The barracks were converted into the Mira Loma Apartments. The runaway was extended to 4,517 feet on 242 acres.

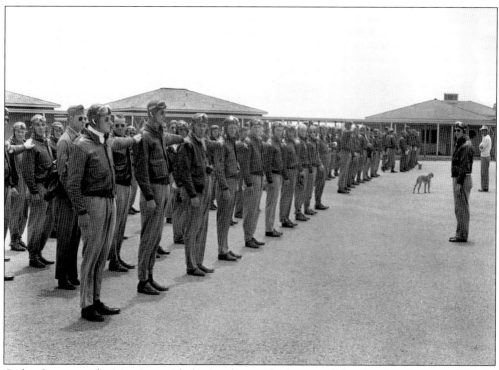

Cadets line up at the Mira Loma Flight Academy, which opened shortly after the start of World War II and was located off Fifth Street and west of Ventura Road.

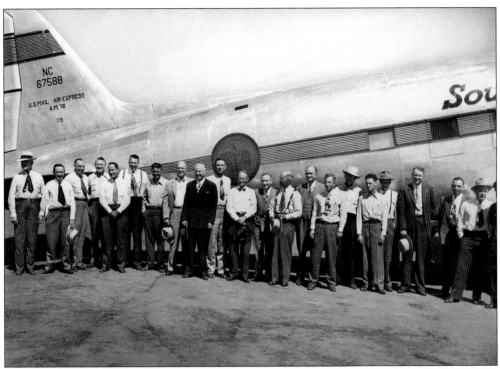
Local businessmen line up in front of the U.S. Air Express Mail plane flown by Southwest.

The Ventura County Grand Jury and Santa Paula Aeronautic class visit the U.S. Naval Air Missile Test Center at Point Mugu, California in November 1948.

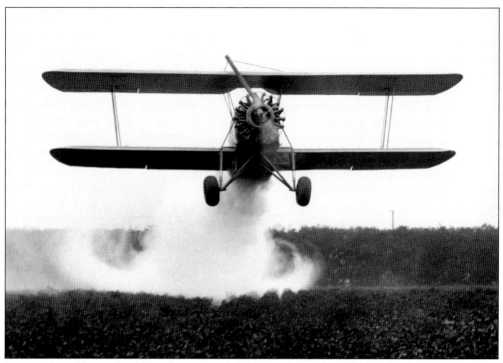
Tom McLoughlin parlayed his flying experience into a crop dusting occupation.

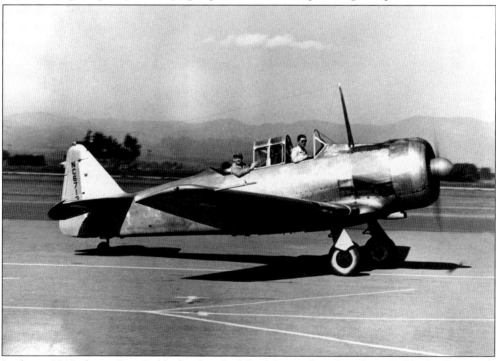
In this *c.* 1947 photo, Stan Pidduck takes Carl Beal for a ride in his plane. Pidduck, along with Ventura farmer Charles Kimball, met an untimely death a few years later when Pidduck's Beechcraft Bonanza collided with a Cessna 172 near the Riverside airport.

Two
THE BOULEVARD

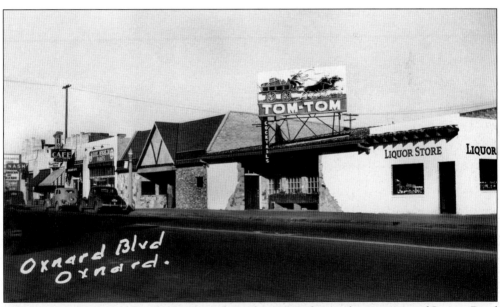

This is a c. 1950 view of Oxnard Boulevard. By the 1950s, the northern portion of Saviers Road was renamed Oxnard Boulevard—from the "five points" intersection at Wooley Road and northbound toward the 101 Highway. The boulevard became home to as many as 12 auto dealerships, as well as several restaurants and other businesses.

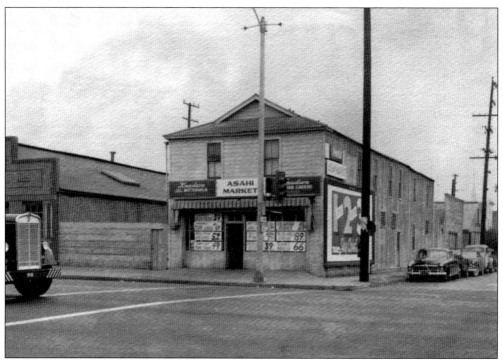
Pictured c. 1940 at the corner of Oxnard Boulevard and Seventh Street is Asahi Market, which was established in 1907 to service the needs of the Japanese community.

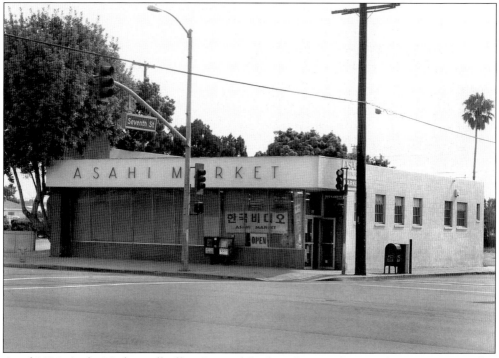
As of 2004, Asahi Market still offers Oriental food products and items almost 100 years after opening its doors to the public.

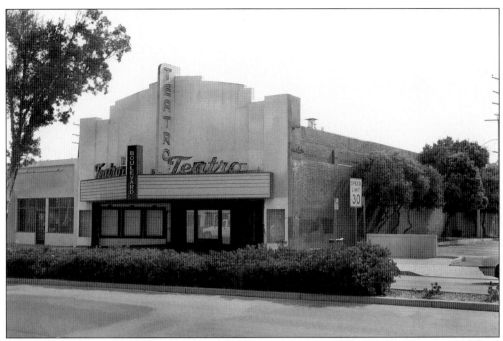

The Teatro at 624 Oxnard Boulevard offered Spanish-language films as early as the late 1940s. The theater closed down during the latter part of the century, but has served as a recording studio and church. Artists who have recorded or had their music remastered there have include Daniel Lanois, Bob Dylan, and Willie Nelson.

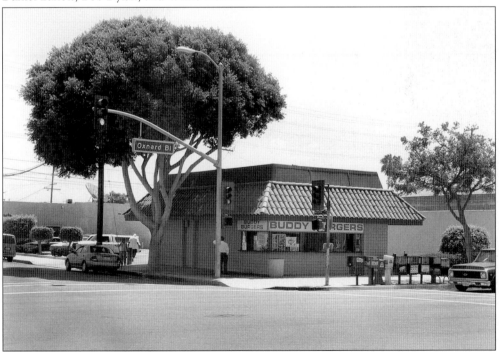

Buddy Burgers on Oxnard Boulevard and Seventh Street is the offshoot of Wimpy's and was opened by Ernie and Ethel Wood in the early 1970s.

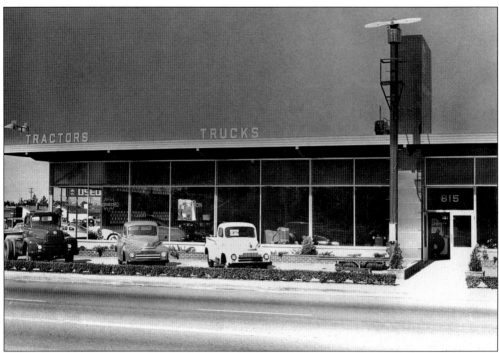

Oxnard Boulevard was home to the car and truck dealerships of Oxnard, including the Maulhardt Equipment Company (above). The tractor and truck dealership opened in 1939 at 350 Oxnard Boulevard. When the business expanded to include a Buick dealership (below), the tractor and truck business was relocated farther north at 815 North Oxnard Boulevard.

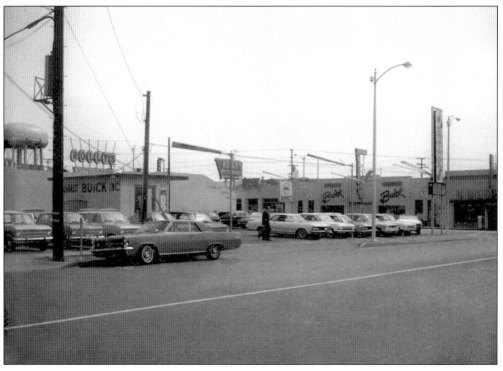

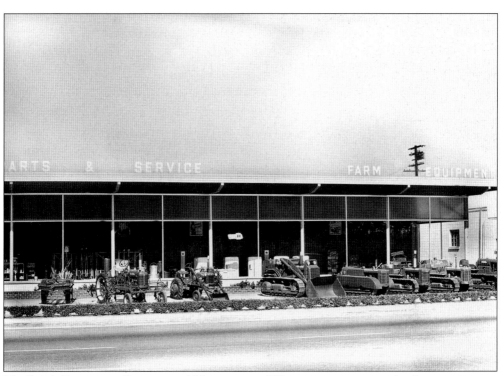

Maulhardt Equipment Company sold International Harvester tractors, trucks, farm equipment, and wind machines.

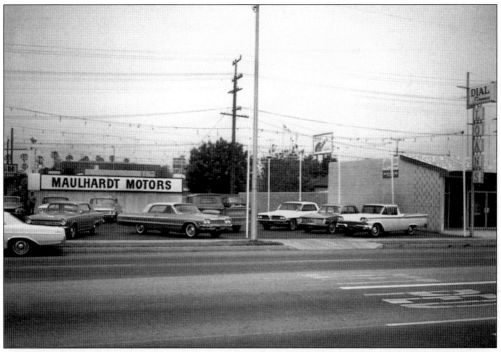

After the Buick dealership was sold to Don Monday, Maulhardt Motors opened at 837 South Oxnard Boulevard.

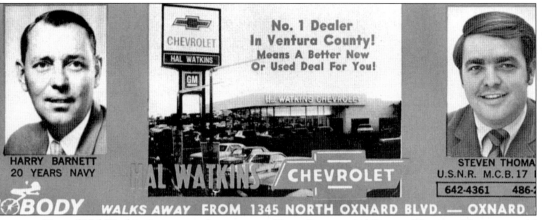

Two of Hal Watkins's top car salesman were Harry Barnett and Steven Thomas. Thomas would go on to buy his own successful BMW dealership in Camarillo.

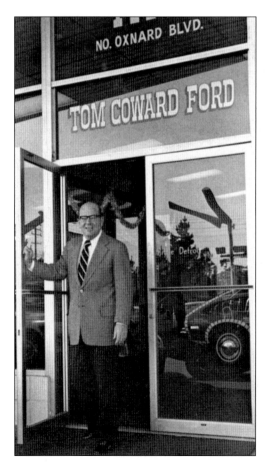

Tom Coward Ford operated his Ford dealership at 1111 North Oxnard Boulevard.

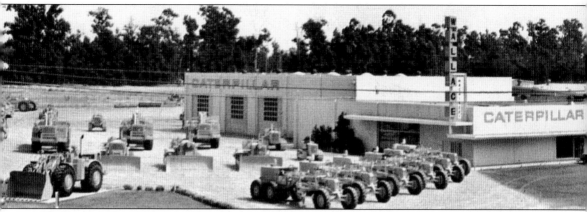

Wallace Machinery Company opened in 1944 at the corner of Rose Road and 101 Highway, and offered Caterpillar and John Deere products.

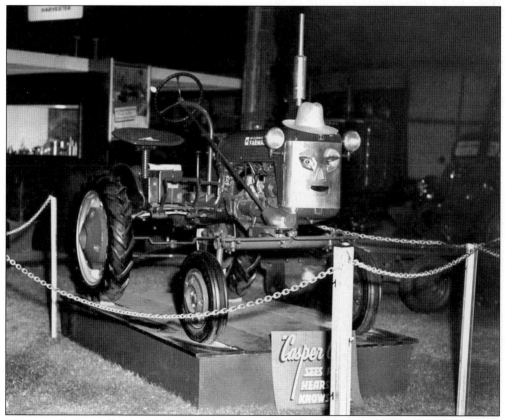

"Casper" the Farmall tractor was advertised to see all, hear all, and know all.

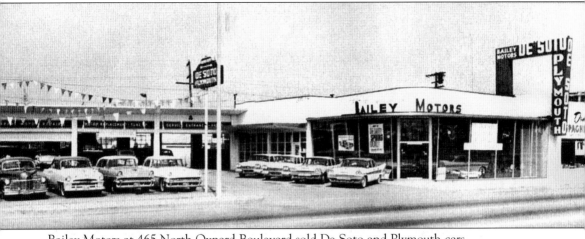
Bailey Motors at 465 North Oxnard Boulevard sold De Soto and Plymouth cars.

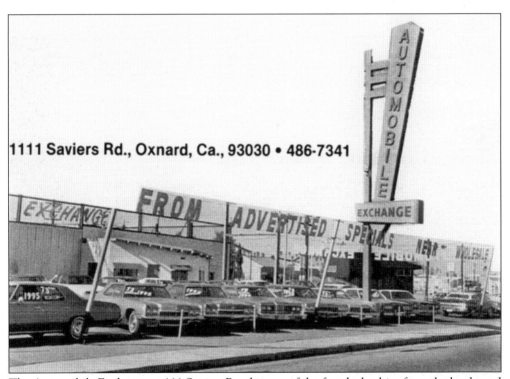
The Automobile Exchange at 111 Saviers Road is one of the few dealerships from the boulevard that has survived into the current century.

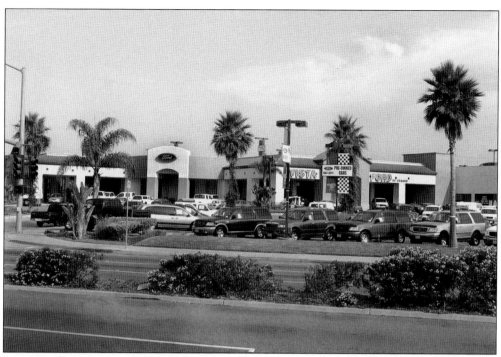

By 2000, the majority of car dealers relocated across the 101 Freeway to Auto Center Drive, between Rose Avenue and Rice Road. The Ford dealership became Vista Ford.

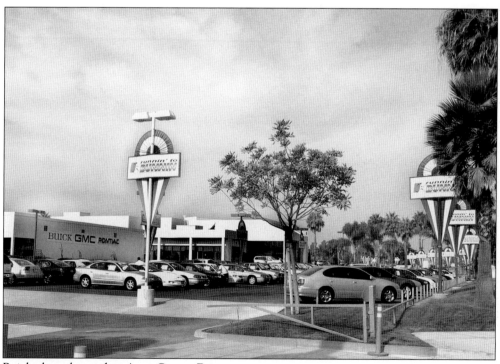

Buick also relocated to Auto Center Drive.

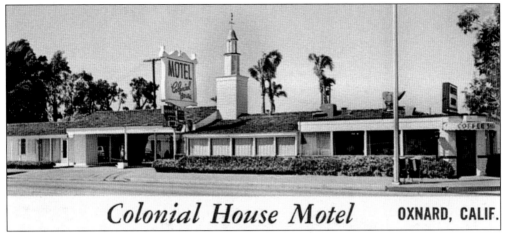

Colonial House Motel — OXNARD, CALIF.

In the early decade of the 1940s, the future Colonial House was a rickety old, tiny drive-in restaurant. Martin "Bud" Smith remolded the restaurant with the help of Ed Carty. With the help of his mother, his sister, and his wife, Smith was on his way to his first of many moneymaking investments that grew to millions of dollars in real estate in Ventura County.

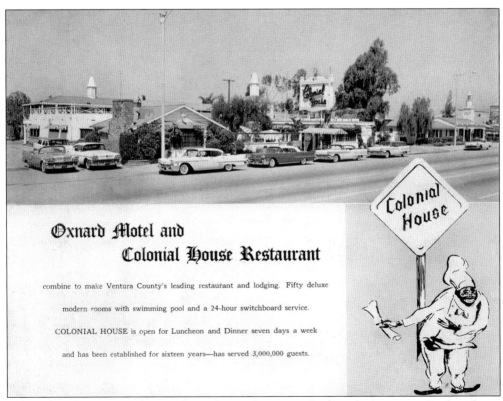

The Colonial House was known for its hospitality, great food, and advertising. In this photo, an employee in a chef's outfit stands along the roadway and waves a bell to attract customers to the restaurant.

Three
A Street and Beyond

The Redevelopment Agency was formed in 1960. Plans for converting A Street into the Plaza Park Mall began in 1969. As part of the rehabilitation of the downtown area, 58 buildings were demolished and 62 buildings renovated.

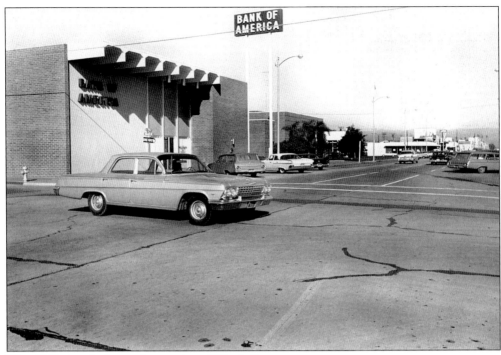

This 1962 view looks north past A and Ninth Streets.

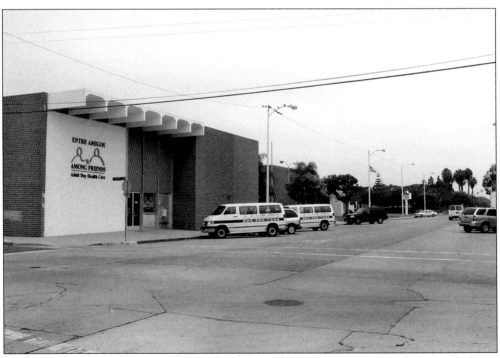

Bank of America on the corner of A Street and Ninth has been replaced with Enter Amigos–Adult Day Health Care.

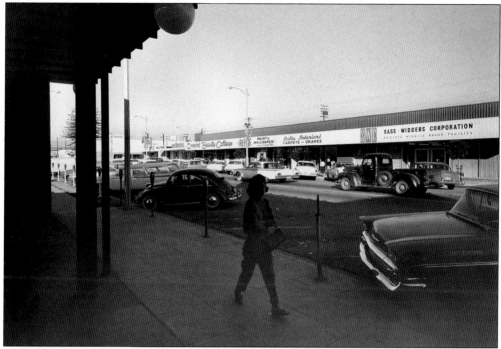

This 1962 view of A Street looks north from the middle 700 block.

Taken in 2004, this photo shows A Street from the middle 700 block, looking north.

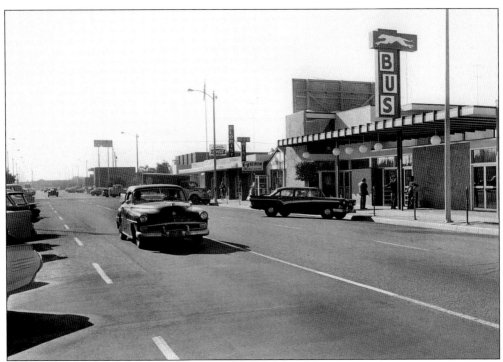

The original Greyhound bus station was located on the west side of A Street, between Eighth and Seventh Streets.

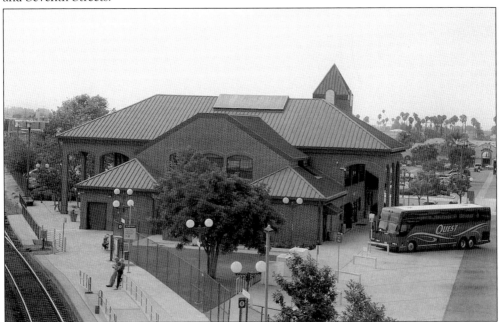

The Oxnard Transportation Terminal was completed in the 1980s. The structure was funded by Caltrans and the City of Oxnard. The terminal provides transportation services for Amtrak, Metrolink Commuter, Greyhound, South Coast Area Transit, the City of Oxnard, and Country Transit.

As early as 1985, the Community Development group began working with several of Oxnard's notable families and investors to create a downtown business center utilizing old turn-of-the-century farmhouses to create Heritage Square.

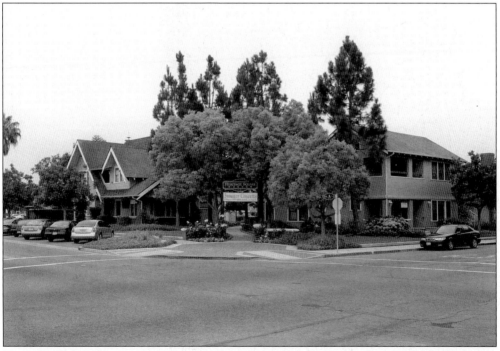

Heritage Square hosts a summer concert series, tours of the houses, the Petit Playhouse, weddings, and special events. (Courtesy of the author.)

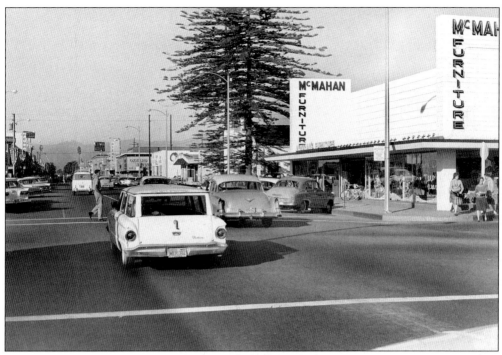

This is a 1963 view of A Street from Seventh, looking north.

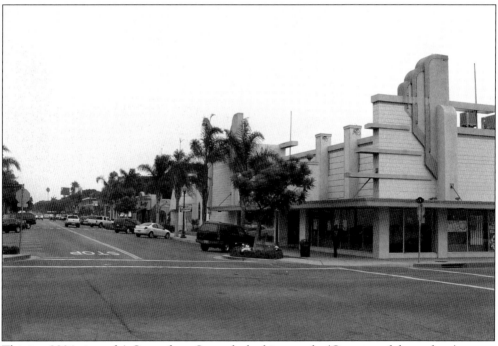

This is a 2004 view of A Street from Seventh, looking north. (Courtesy of the author.)

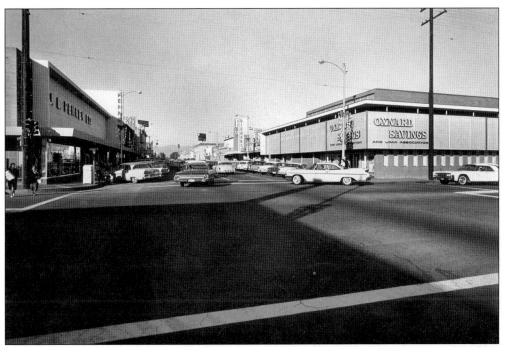

This is a 1962 view of A Street at Sixth Street, looking north.

This is a 2004 view of A Street at Sixth Street, looking north. (Courtesy of the author.)

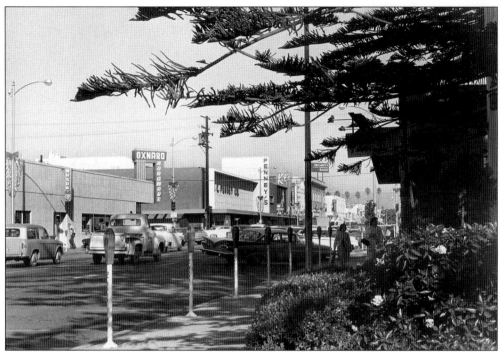

This is a 1962 view of A Street at the middle of the 600 block, looking north. Several of the businesses included Oxnard Hardware, JC Penney, Kit's Palomino Club, a sporting goods store, the Oxnard Theatre, and Security First National Bank.

This 2004 photo shows A Street at the middle of the 600 block, looking north.

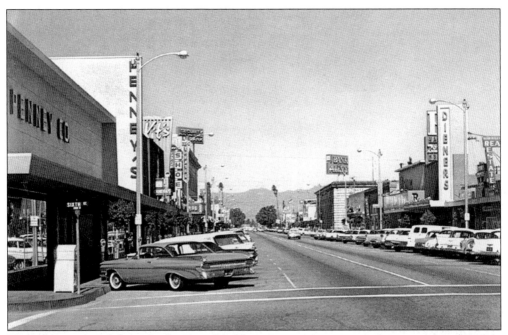
This 1960s postcard shows both sides of A Street.

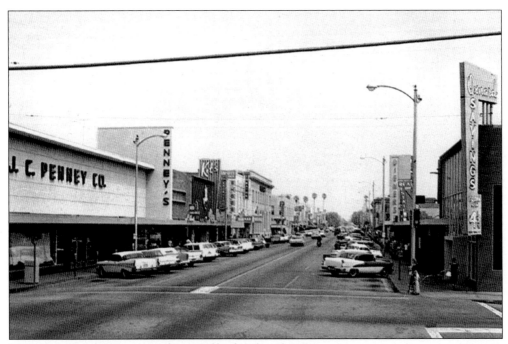
Here is another 1960s postcard view of both sides of A Street.

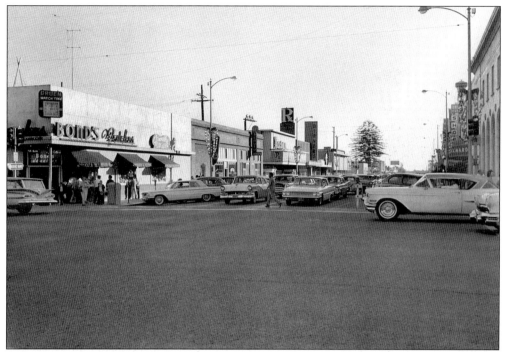

This 1962 view of A Street looks south from Fifth Street. In business at the time were Bond's Jewelers, a tailor shop, a beauty shop, a drug store, Dieners clothing store, a real estate office, and Oxnard Savings and Loan.

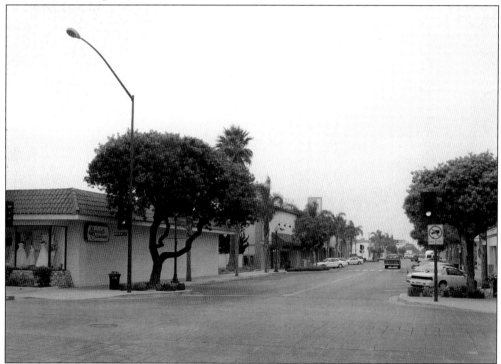

This 2004 view of A Street looks south from Fifth Street. (Courtesy of the author.)

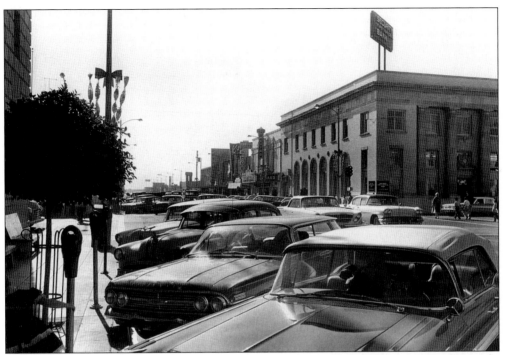

This 1962 view looks south from Fifth Street to the west side of A Street.

This 2004 view of the west side of A Street looks south from Fifth Street. (Courtesy of the author.)

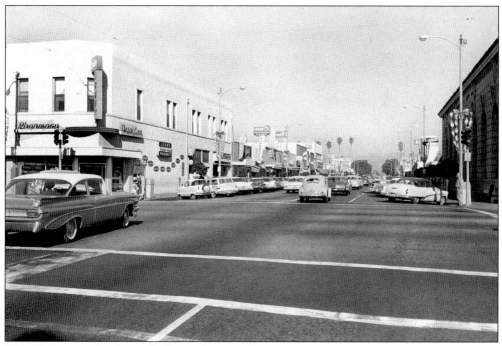

This 1962 view of A Street looks north from Fifth Street.

This 2004 view of A Street also looks north from Fifth Street. The vacant lot on the left is being prepared for the downtown multiplex theater.

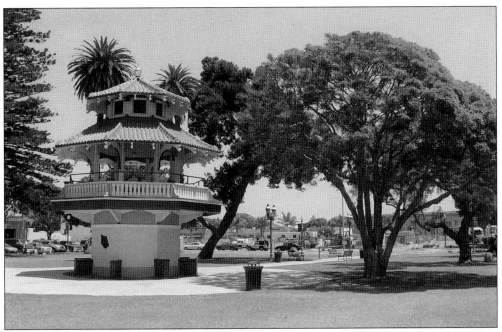

This photo of the Pagoda was taken in July 2004. Note the vacant lot in the background, which was cleared to make way for a multi-screen movie theater.

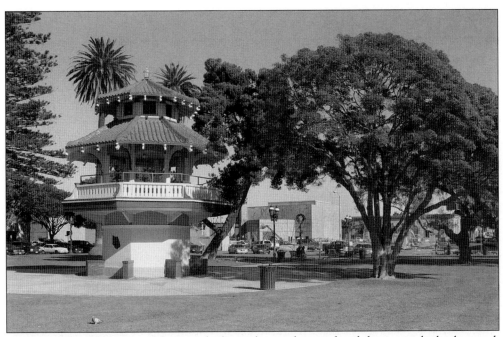

This December 2004 view of the Pagoda shows the nearly completed theater in the background. The new theater project also includes a four-level parking structure.

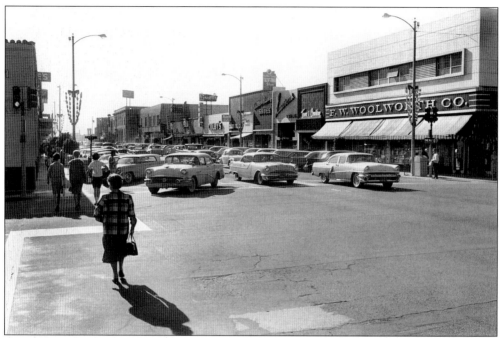
This 1962 view of A Street looks south from Fourth Street. Businesses included Woolworth, Town & Country, See's Candies, an optometrist's office, Linnet's Shoes, Rubert's Household Loans, and the Blue Rose Cafe.

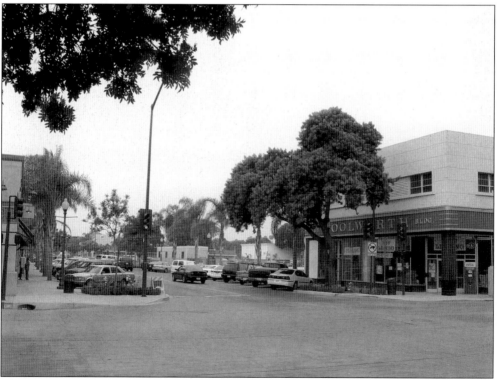
This 2004 view of A Street looks south from Fourth Street. (Courtesy of the author.)

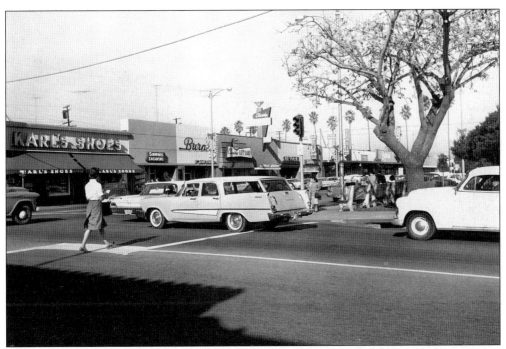

This 1962 view of the west side of A Street looks north from Fourth Street.

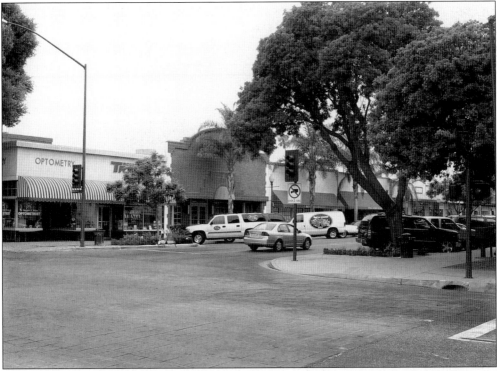

This 2004 view of the west side of A Street looks north from Fourth Street. (Courtesy of the author.)

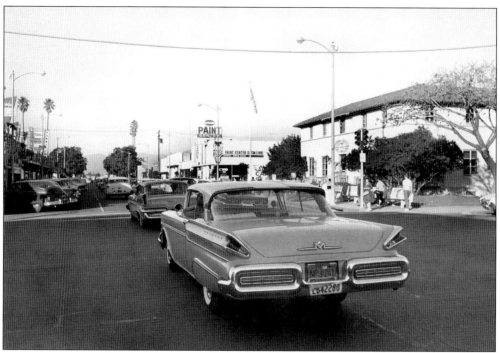
This 1962 view of the east side of A Street looks north from Fourth Street.

This 2004 view of the east side of A Street looks north from Fourth Street. (Courtesy of the author.)

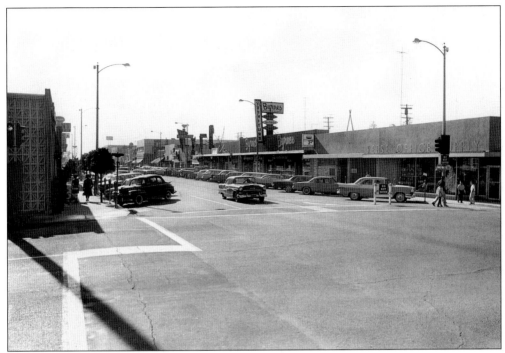

This 1962 view of the west side of A Street looks south from Third Street.

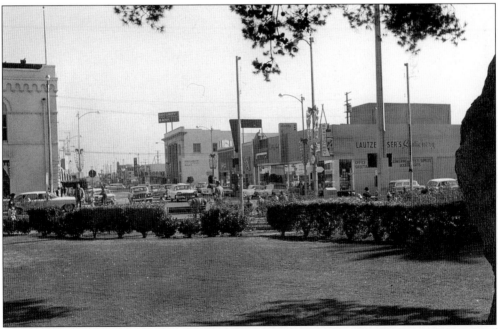

This 2004 view of the west side of A Street looks south from Third Street. (Courtesy of the author.)

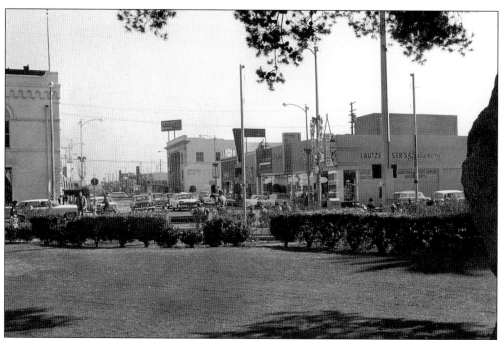
This 1962 view from Plaza Park looks east toward Fifth Street.

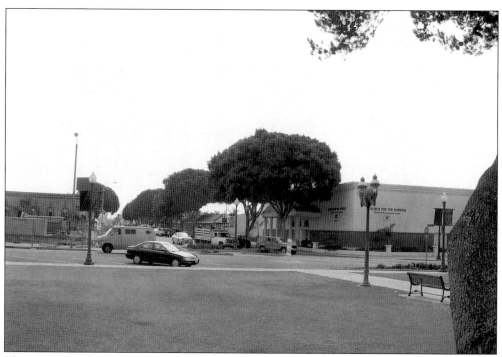
This 2004 view from Plaza Park looks east toward Fifth Street. (Courtesy of the author.)

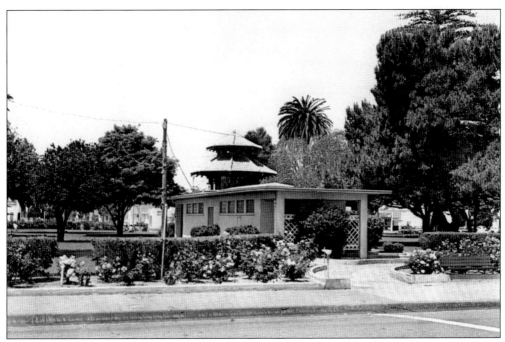

This c. 1969 view of Plaza Park shows the Pagoda Bandstand in the background and the restrooms in the foreground.

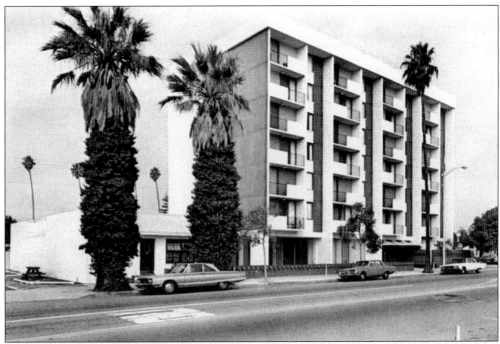

This 1960s view of the Plaza Vista includes the Oxnard Housing Authority's high-rise apartment building for senior citizens on C and Fourth Streets.

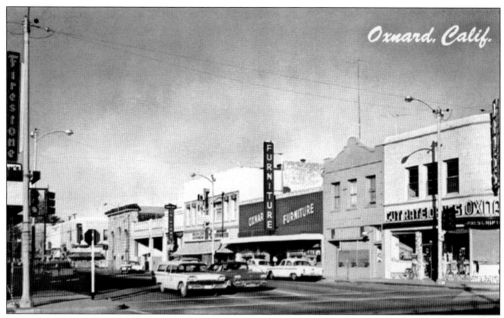
This pre-1969 view of Fifth Street looks west from Oxnard Boulevard. Many of these brick buildings were demolished starting in 1969.

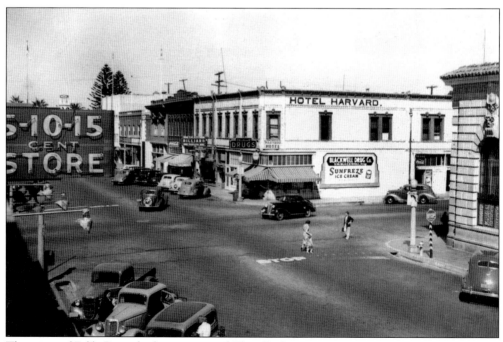
This view of Fifth Street looks west toward Plaza Park.

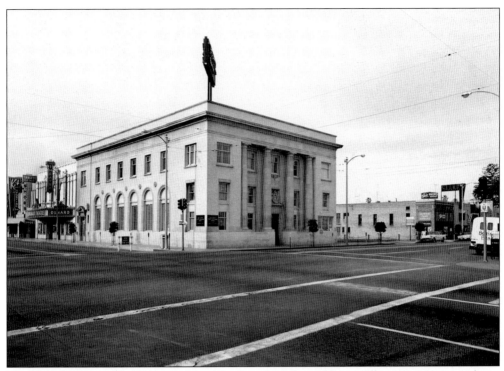

The First Interstate Bank was designed by Los Angeles architect Albert C. Martin and was located at the corner of Fifth and A Streets, catty-corner to the Bank of A. Levy. The building was torn down during the 1969–1970 renovation of Plaza Mall.

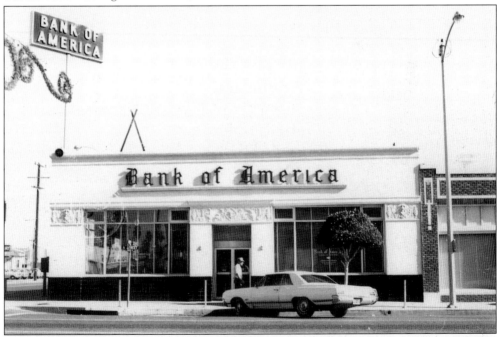

Bank of America was located at the corner of Fourth and A Streets and across the street from the Woolworth building.

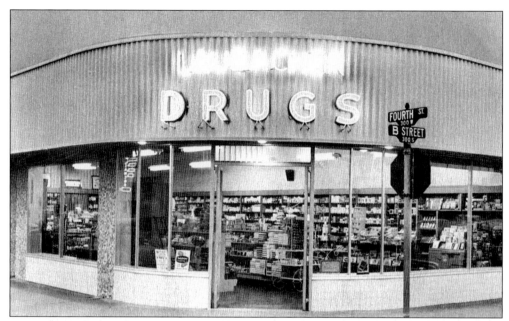

At 301 West Fourth Street, Mike Laubacher offered "complete pharmaceutical services" for several decades.

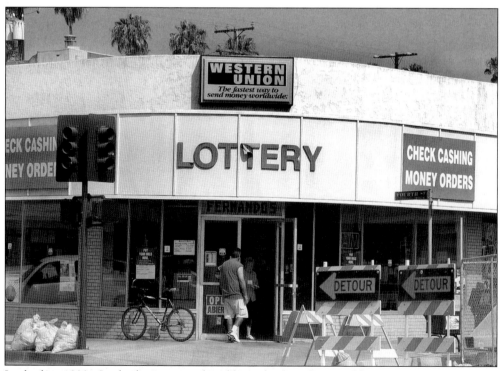

In the late 1990s, Laubacher's was replaced by a check-cashing and lottery store.

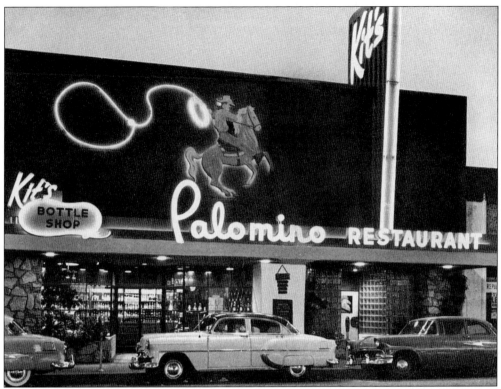

James Cooluris owned Kit's Palomino Restaurant at 533 A Street. It featured seafood dishes and charcoal-broiled steaks.

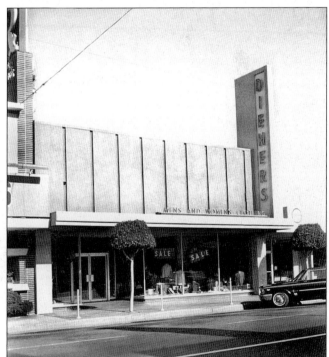

Albert C. Diener opened Diener's "Smart Men's Wear" in 1913 at 534 A Street. Walter Diener carried on his father's tradition until the 1960s.

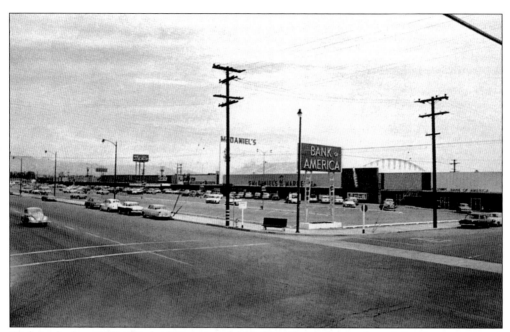

Back in the late 1950s, Bank of America and McDaniel's market anchored the shopping center at the corner of Saviers Road and Channel Island Boulevard.

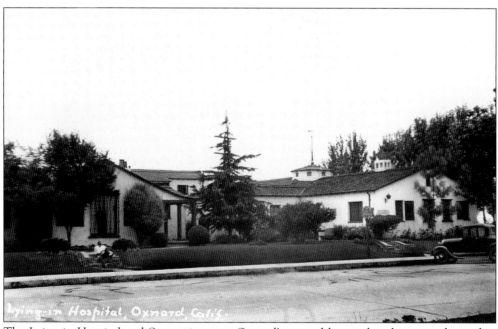

The Lying-in Hospital and Sanatorium was Oxnard's second hospital and was was located at 846 West Fifth Street.

Foraichi Otani opened a poolroom on Oxnard Boulevard c. 1907. A few years later, the Otani brothers opened a produce market. Recently, the Otani family has operated a fish market on A Street.

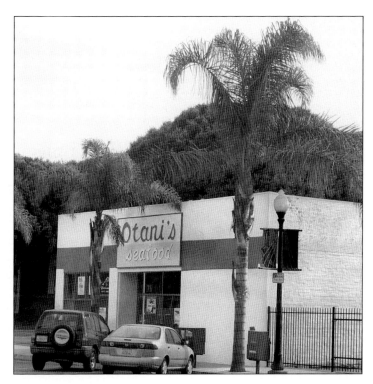

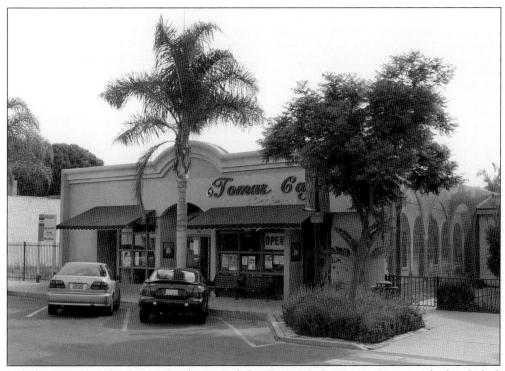

In February 2001, the Garcia family opened the Tomas Cafe. Tomas Garcia is the head chef. The Garcias also own the mortuary across the street.

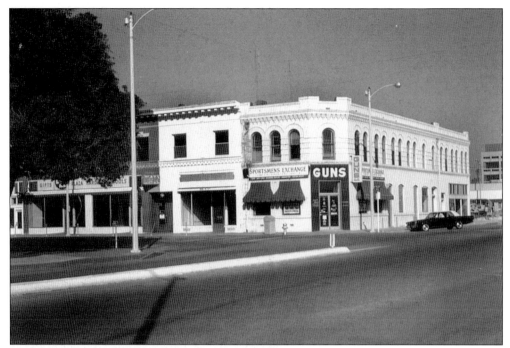

At Plaza Park and B Street, these brick buildings were the first to be designed by pagoda architect Alfred F. Priest. Before it was a gun shop, the corner building was home to Oxnard's first bank, the Bank of Oxnard.

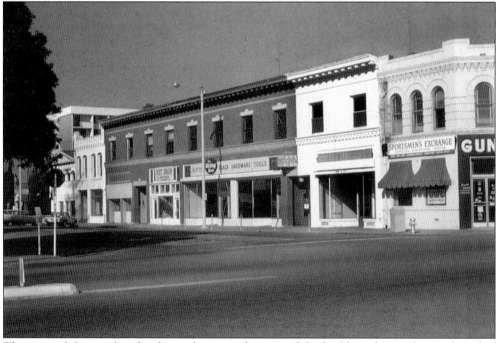

The original Covarrubias hardware shop was also part of the buildings lining the north end of the Plaza Park.

Peacock's Confectionary started by selling ice cream and candy back in the early part of the century. By mid-century, Peacock's was peddling the latest entertainment craze—records.

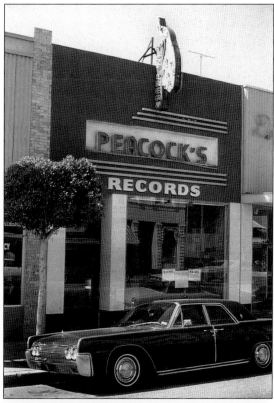

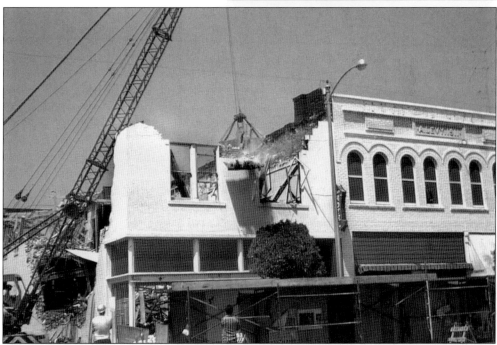

The original 1902 Levy building, at the corner of Fifth and B Streets, became a victim of the wrecking ball during the 1969–1970 downtown redevelopment.

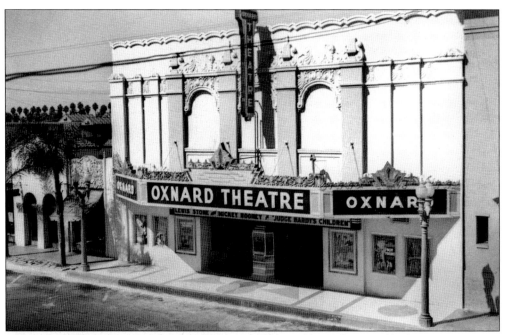

The Oxnard Theatre at 519 South A Street was designed by architect Alfred Priest in 1920.

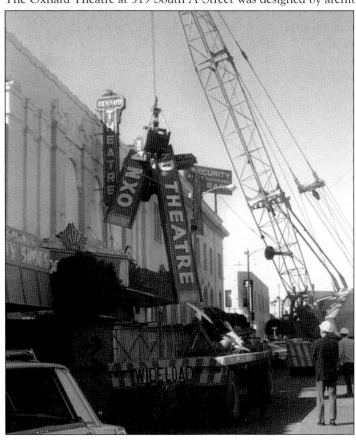

The Oxnard Theatre also fell victim to "progress" in late 1969.

In 1951, the Vogue Theatre featured the Dean Martin and Jerry Lewis film *At War with the Army*.

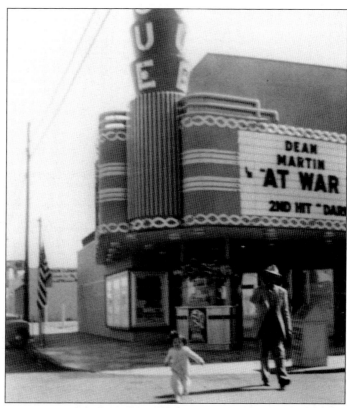

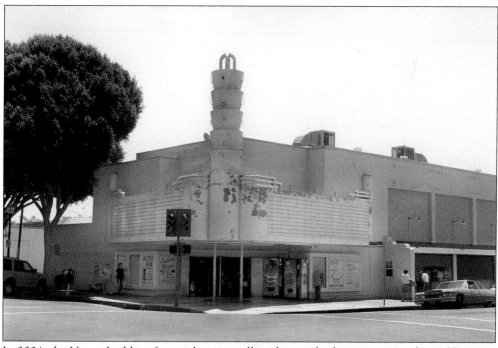

In 2004, the Vogue building featured a store selling fruit and other grocery products. (Courtesy of the author.)

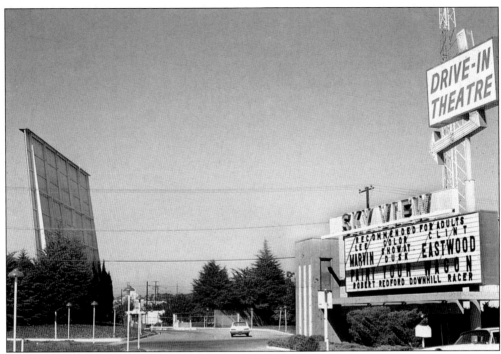

At the Sky View Drive-In Theatre, families and couples could view the latest movies on a large screen without leaving their car.

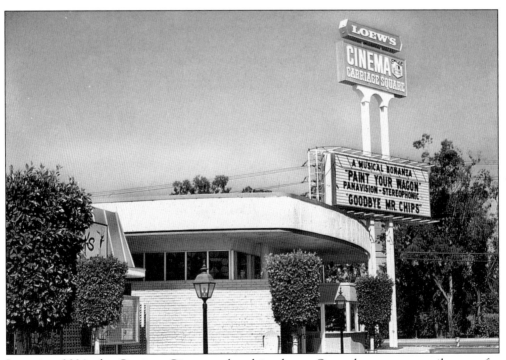

In spring 2004, the Carriage Cinemas closed its doors. Oxnard was temporarily out of a movie house.

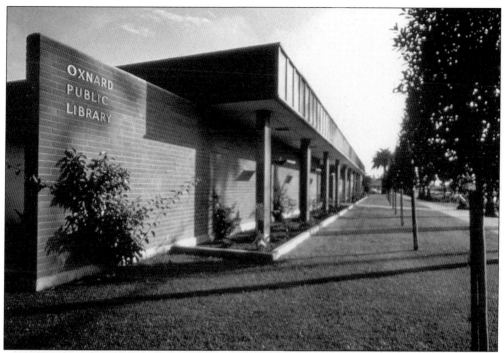

The second Oxnard library was located at C Street, between Second and Third Streets. It was completed in 1963 at a cost of $372,000. (Courtesy of the author.)

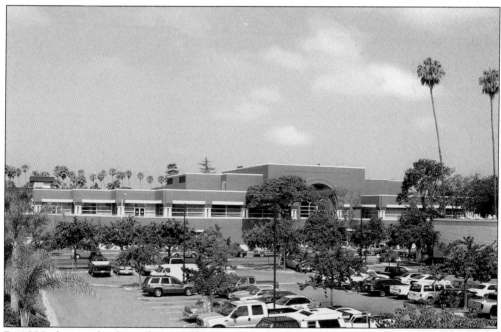

By 1988, the cost for the architectural plans alone for the new library at A Street between Third and Second Street was almost $900,000. The total cost for the two-story, 72,000-square-foot library came to over $12 million dollars.

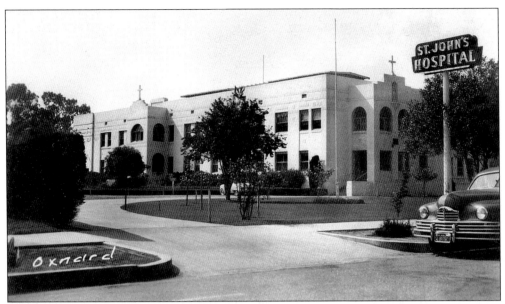

The original St. John's Hospital was completed in 1914 and located at 333 North F Street. When people speak of Oxnard as the home of "beans, beats, and babies," here is where the "babies" are born. Women from across the country would travel to St. John's to take part in the "twilight sleep" procedure. The method included "reduction of stimuli for the patient by lowering the lights and noise." Oxnard's Dr. Robert Livingston traveled to Freiburg, Germany, to learn the technique. He became a leading expert in the field.

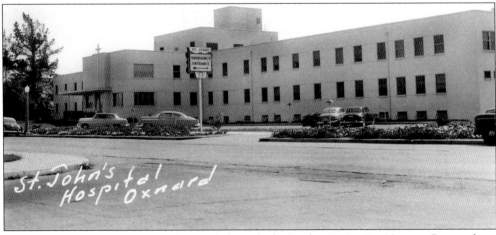

By 1952, St. John's was expanded to include 75 beds. By the 1950s, Dr. Herman Roy took on the task of performing the "twilight sleep" procedure.

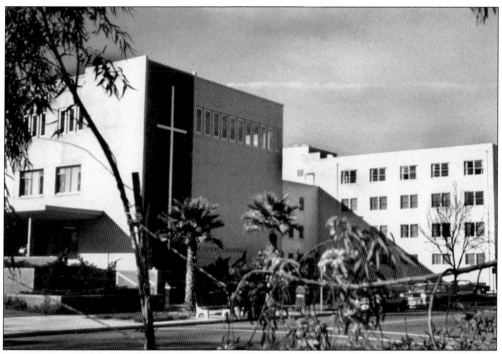

By the 1960s, the hospital had 316 beds, 4 stories, a basement, and a helicopter landing pad.

To keep up with the growing population St. John's was relocated in 1991 to Gonzales and Rose Avenue. (Courtesy of the author.)

Originally built to replace the burned down Oxnard Grammar School, Roosevelt School was later converted to the city hall.

The Roosevelt building was replaced by the current three-story structure located at Third Street.

Four
OXNARD GROWS

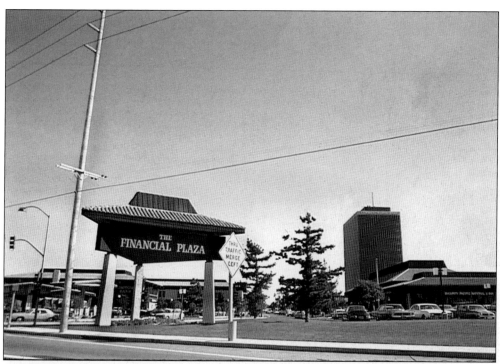

In 1974, Bud Smith created the Oxnard Financial Plaza at the corner of the 101 Freeway and Vineyard Avenue. Smith built the first skyscraper in the county, the 15-story Financial Plaza Tower, pictured on the right. He later added a second, 24-story tower.

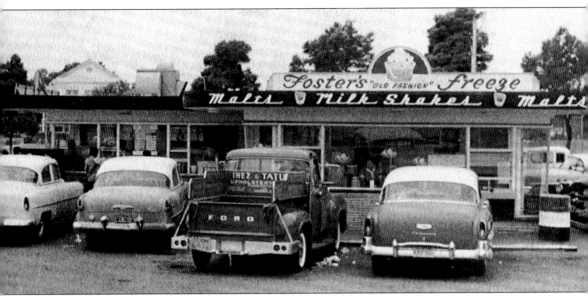

Foster's Old Fashion Freeze was located at 310 North A Street. In 1948, a banana split cost 40¢. Once part of the Gisler ranch, Foster's Freeze gave way to Win's Drive In, home of the "Billy burger" and the hard shell taco.

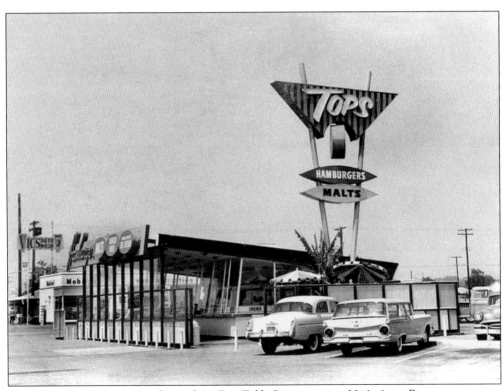

Tops drive-in restaurant was located on East Fifth Street next to Vic's Auto Parts.

Co-owners Alvin Behrens and Carlo Silvio offered a unique service for customers by providing drive-in/drive-out service at two locations, one at 125 Palm Drive (pictured) and the other still operated by Vince Behrens at 535 South C Street.

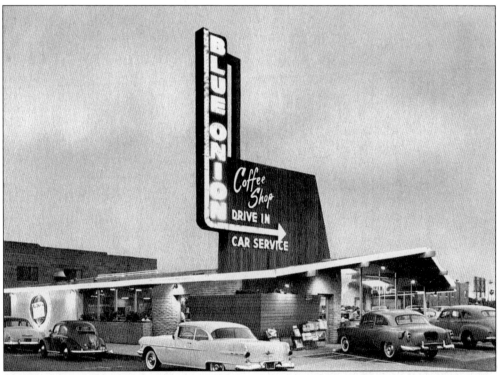

The Blue Onion Drive-In Restaurant at 733 South Oxnard Boulevard featured a six-page menu filled with "taste-tempters to please the heartiest or finnickiest appetite."

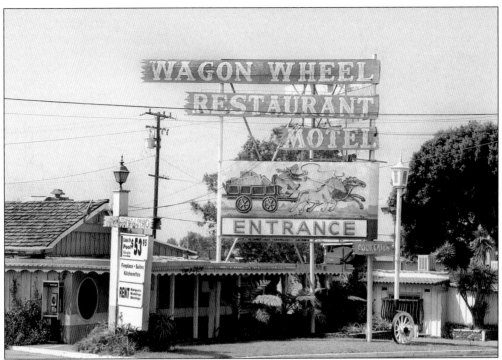

In 1946, Bud Smith started his second business venture, the Wagon Wheel Junction. The Western-style restaurants, motel, and businesses welcomed visitors traveling along the 101 Freeway. (Courtesy of the author.)

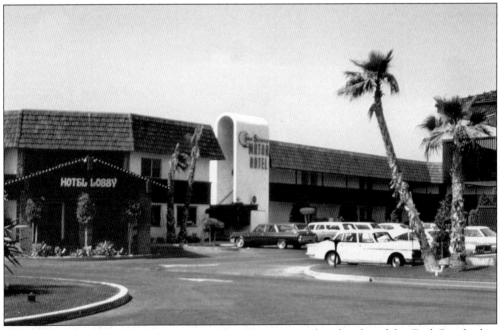

The Lobster Trap Restaurant was part of a 40-acre complex developed by Bud Smith that included the Casa Sirena Hotel, a 120-unit apartment complex, the Villa Serena, and a dock with boat slips.

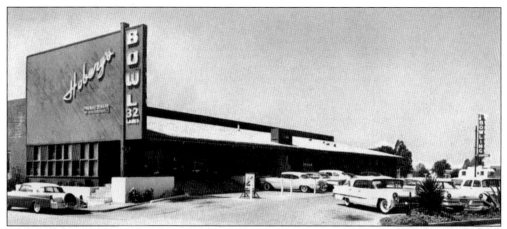

Ed Hoberg owned the Wagon Wheel Bowl (pictured in 1958), located at 2801 Wagon Wheel Road. European bowlers used nine pins. Americans added a tenth pin to sidestep laws against "ninepin" gambling. By 1952, "pin boys" were replaced by pin setting machines. NBC Television helped popularize the game with its *Championship Bowling* broadcast in 1954.

The Tournament Bowl at 3443 Saviers Road opened its doors to the public in 1958 on the old Charles Donlon Ranch. Owners Jim and Kit Knight offered 24-hour service and 32 bowling lanes.

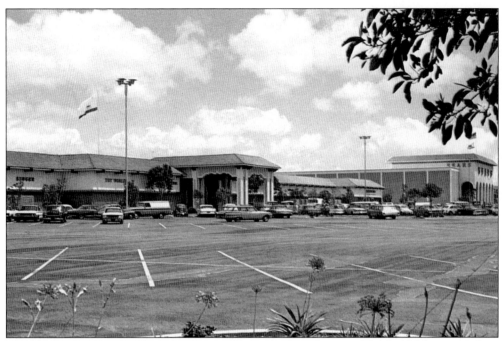

The 45-acre Esplanade Shopping Center began its first phase in March 1970 as an indoor shopping mall anchored by Sears on the south end and Robinson May Company on the north end.

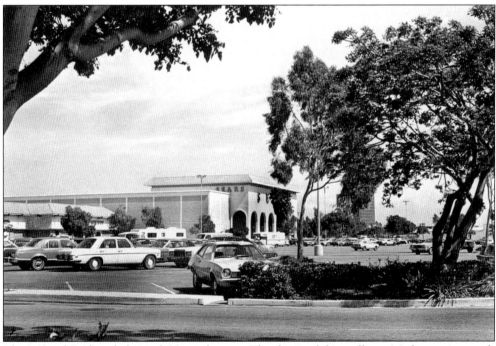

The original Esplanade housed 55 retail stores. The decor of the mall was Mediterranean with red tile roofing and wrought-iron accents.

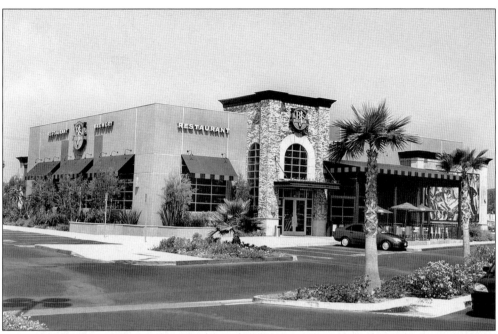

By the late 1990s, business at the mall was down. When the anchor stores, Sears and Robinson May Company, decided to leave, the city council made a bold move to demolish the mall and rebuild a new set of stores. Since 2003, BJ's Brewery has offered Chicago-style pizza and house-brewed beer, and has become one of the many popular spots at the new Esplanade. (Courtesy of the author.)

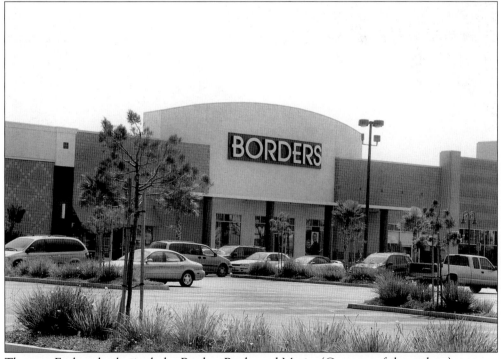

The new Esplanade also includes Borders Books and Music. (Courtesy of the author.)

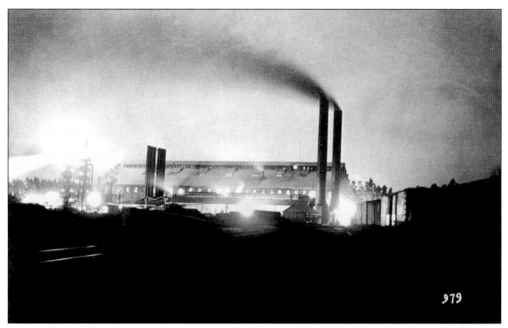

By October 1958, the original cornerstone of the community, the sugar factory that brought about the town of Oxnard, closed its doors for the last time. Sugar beet production was down to 4,000 acres, not even enough to process at the plant. By the following year, the largest of the brick structures was torn down.

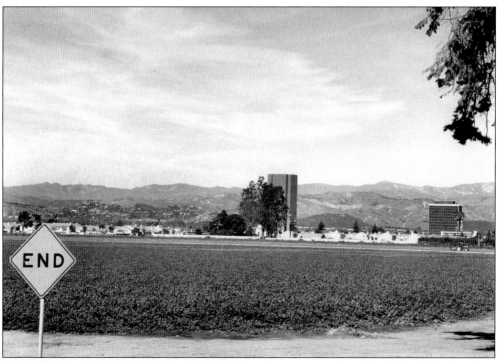

Oxnard's agricultural livelihood has given way to skyscrapers and residential neighborhoods.

Five
People

The Naval Construction Battalion Center in Port Hueneme brought a whole new population to the area. After World War II, many returned to stay.

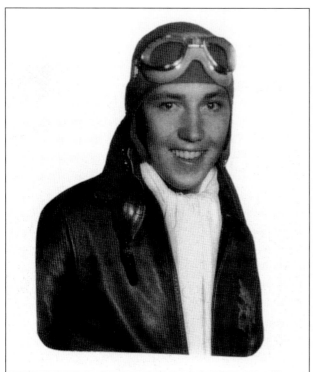

Pictured in 1943, Lt. Ed Weigel flew 79 missions from Manila to Japan during last years of World War II. He was a member of the Flying Knights, who were led by highly decorated pilot Col. Gerald R. Johns, the subject of the book *Jungle Ace*. Weigel was part of the original Thunderbirds when he, along with Maj. James Watkins and Lt. Ray Lierley, represented the 49th fighter group, 5th Air Force in an air show over Meiji Stadium, Tokyo, on November 11, 1945.

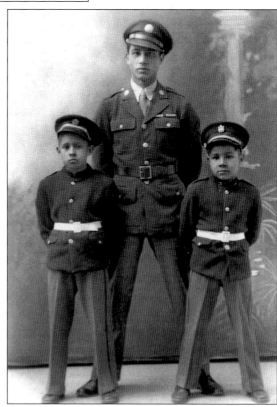

Richard Valles (left) and Bob Valles (right) are "at ease" with their uncle, Henry Valles Piña.

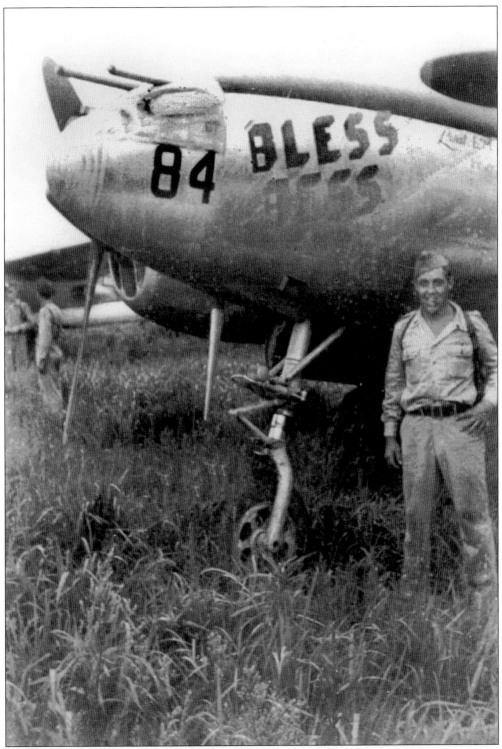

First Lt. Ed Weigel stands in front of his P-38 plane at Atsugi Air Base, Japan, on August 31, 1945, two days before the armistice was signed on the battleship *Missouri*.

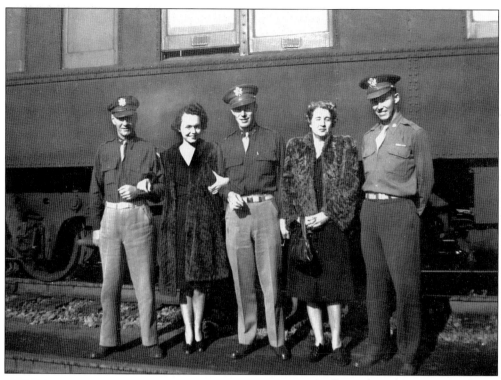

Oxnard residents prepare for a train ride to flight training. Ed Carty Jr. (far right) stands next to his mother, Doris. Carty was one of several soldiers from Oxnard who lost their lives during World War II. Carty died during flight training out in the desert.

This photo of Oxnard resident Tom Horikawa was taken at Camp Roberts in October 1941.

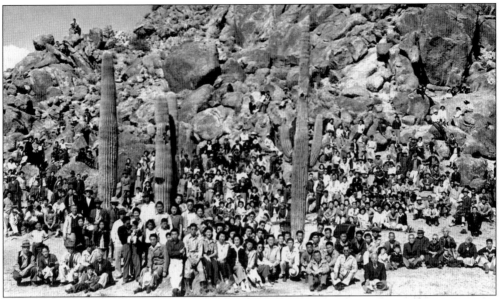

This is a group photo of the interned Japanese at Arizona's Gila Relocation Camp. Many Oxnard families lost several years of their lives at this and similar camps. A total of 343 Japanese were escorted out of Ventura County.

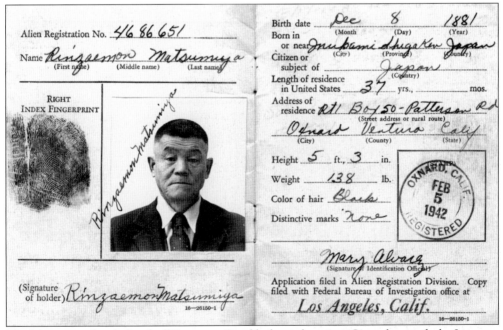

The Matsumiya family lived off Patterson Road before relocation. Once deported, the Japanese were given alien registration cards.

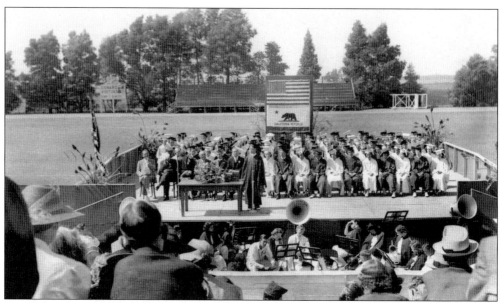

Neo Takasugi was named valedictorian for Oxnard High's class of 1939. Takasugi's future was put on hold when his family and friends were relocated between 1942 and 1945.

Takasugi returned to Oxnard to eventually join Oxnard's city council, and by 1970 he was mayor of Oxnard. He next served as California state assemblyman, 37th district.

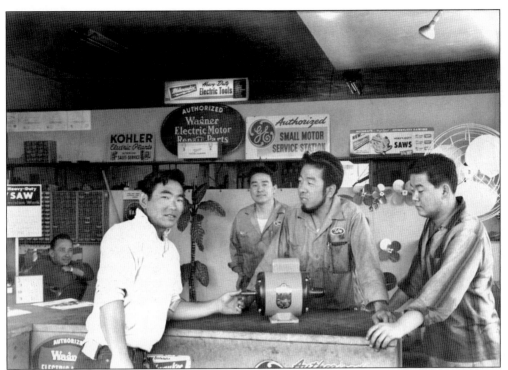

The Moriwaki family returned to Oxnard from the relocation camp and picked up the pieces of their interrupted lives without looking back. The Moriwaki bothers still own Oxnard's Electric Motor Shop at 200 East Fifth Street, providing expert electrical repair services for all types of motors and power tools.

Nagao and Lillie Fujita proved successful examples of Japanese Americans who emerged from the relocation camps with the determination to succeed. Nagao served as an attorney in Oxnard for over three decades, and his wife, Lillie, became a distinguished teacher in the Oxnard school district. This photo is from another of their many accomplishments—35 years of marriage, and many more to come.

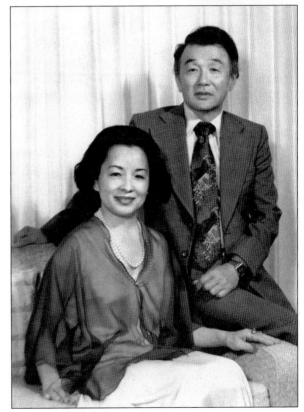

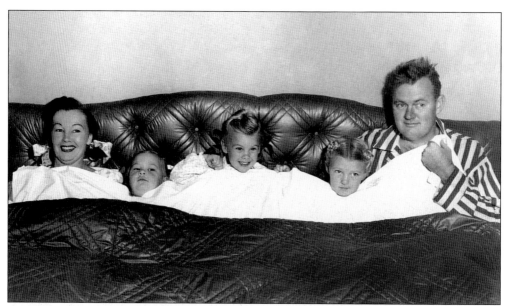

The Martin V. Smith family was always good for a creative Christmas card. Taking from Martha Smith's Hollywood experience, this early Christmas card features their first three children.

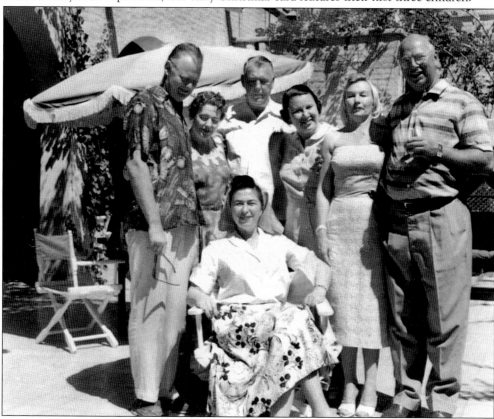

This photo shows Betty Brant (sitting) and, from left to right, Bud Smith, Doris Carty, Ed Carty, Florence Maulhardt, Martha Smith, and Eddie Maulhardt.

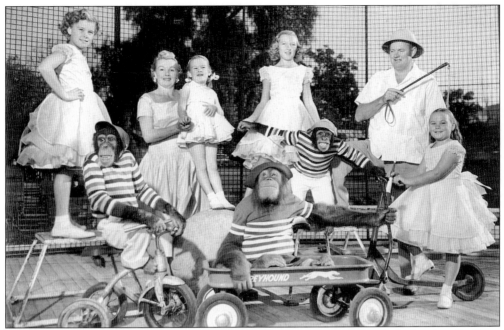

A later Smith family Christmas card adds the fourth Smith daughter . . . and a few friends. From left to right, the Smiths are Margie, Martha, Cindi, Toni, Bud, and Vickie. The photo was taken at Jungleland in Thousand Oaks, California.

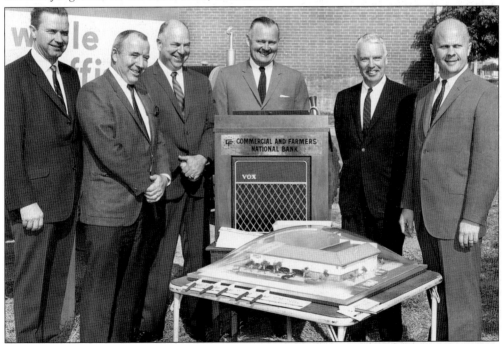

Bud Smith was a son of a banker and always dreamed of owning a bank. In 1965, along with other prominent businessmen, Smith was able to realize his dream and opened the Commercial and Farmers National Bank at 155 A Street. The other men in the photo are, from left to right, Bob Nesen, Bob Lamb, John Maulhardt, Bud Smith, and Dixon Moorehead.

Before 1929, the Ed Carty ranch was located just north of the city of Oxnard. By the early 1930s, Carty developed his ranch. Streets named after his wife and children include Doris Avenue, Robert Avenue, Douglas Avenue, Roderick Avenue, and the cross street named for the family, Carty Street.

Ed Carty served as mayor between 1944 and 1950. The family, from left to right, are Ed Jr., Rod, Patricia, Douglas, Doris, Robert, and Edwin.

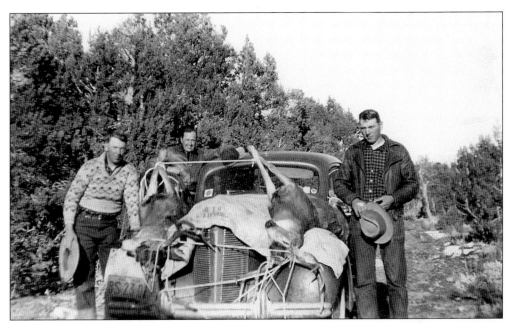

Ed Carty's big-game hunting took him from the jungles of Africa to the wilderness of Alaska. Pictured c. 1945 with their catch on the hood of the car, from left to right, are Ed, a friend, and Ed's cousin, Robert Maulhardt.

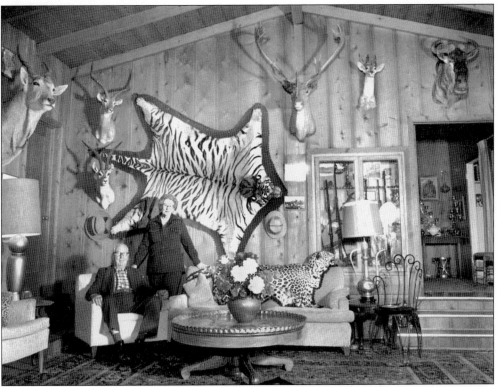

In the days before big-game hunting became politically incorrect, Ed Carty and his wife, Doris, sit in the "animal room" at their house off Roderick Street.

In the 1940s, the Elks sponsored an annual festival and parade during "Sugar Beet Days."

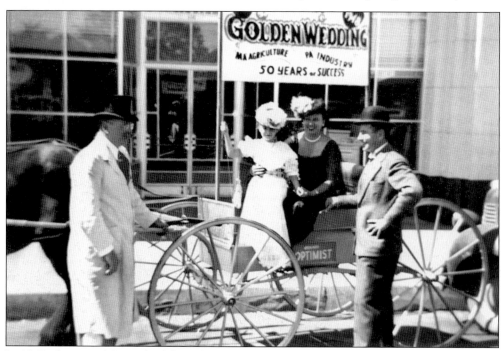
In 1948, the city of Oxnard celebrated 50 years as municipality. Pictured, from left to right, are Eddie Maulhardt, Dena Petit, Florence Maulhardt, and Bud Milligan.

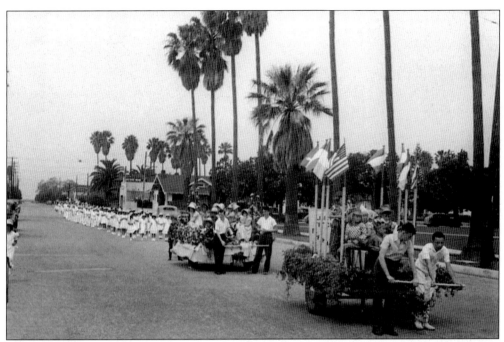

From the 1940s through the 1950s, Oxnard students participated in the annual May Day parade.

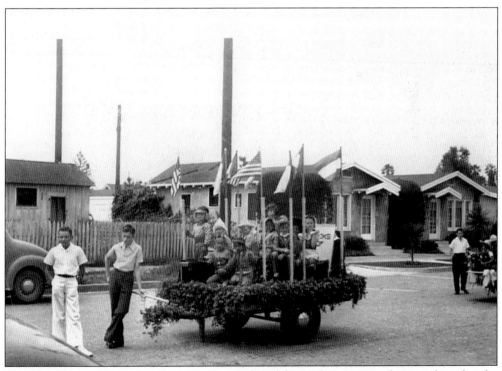

The May Day parade was a chance to not only celebrate the coming of spring, but also the diversity of culture and customs.

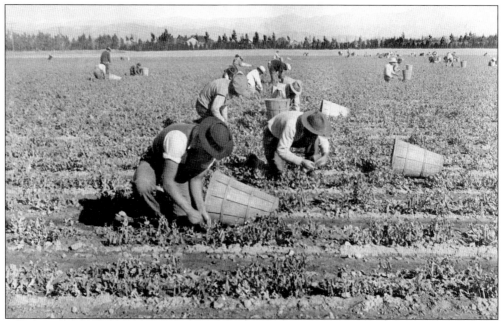

Oxnard has never settled on one crop. Growing peas proved moderately successful during the 1940s but was labor intensive.

Before and after sugar beets inspired the growth of the town, lima beans were Oxnard's most productive crop. As late as the 1960s, Oxnard could still claim to be the "Lima Bean Capital of the World," even though manpower was limited to a small crew. Strawberries eventually replaced the lima bean as well as many of the orchards, but increased manpower was needed to cultivate this more labor-intensive crop.

Threshing of beans evolved from the pitchfork, to the steam engine, to the gas-powered threshing machine.

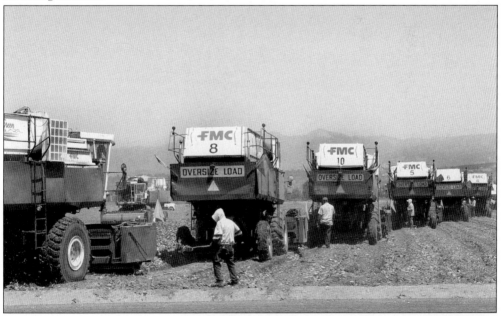

By 2004, a series of threshing tractors could do the job of one machine in far less time and manpower than previous efforts.

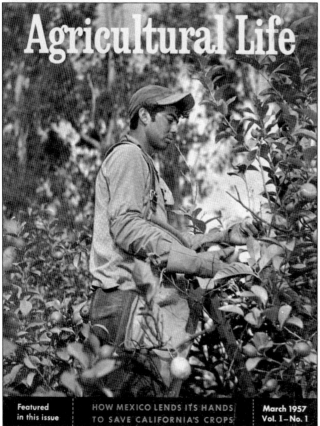

When he was 11 years old, Cesar Chavez and his family lived in a storage building at this site on the corner of Colonia Road and Garfield Street, during the walnut harvesting months of 1938. The site is now designated as Ventura County Point of Interest No. 9. Chavez returned to Oxnard in 1958 in an attempt to form a local chapter of the Community Service Organization (CSO).

The Bracero program lasted from 1942 to 1964 and was an attempt to alleviate the labor shortage caused by United States involvement in World War II. The March issue of *Agricultural* magazine documented the daily life of a bracero.

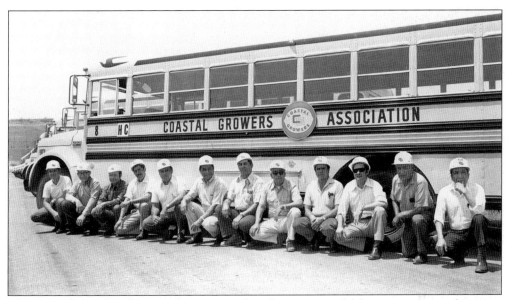

The Coastal Growers Association contracted with growers and laborers to service the citrus industry in Ventura County. Ralph De Leon (far left) was the assistant general manager during the 1970s, and William Jack Lloyd (next to De Leon) was the general manager.

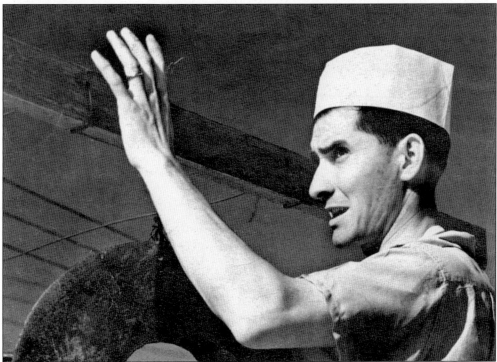

Sam Camacho Sr. came to Oxnard with the Bracero program in 1947. Camacho took over the duties as head cook, and by 1971, Camacho was running the camp for the Coastal Growers Association. When the Coastal Growers decided to bow out of their contract at the camp in 1982, Camacho took over and expanded his clientele to include not only citrus workers, but other farm laborers as well.

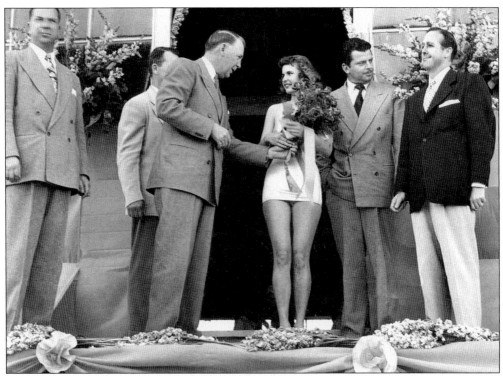
Oxnard mayor Ed Carty congratulates the Harbor Queen in this c. 1947 photo.

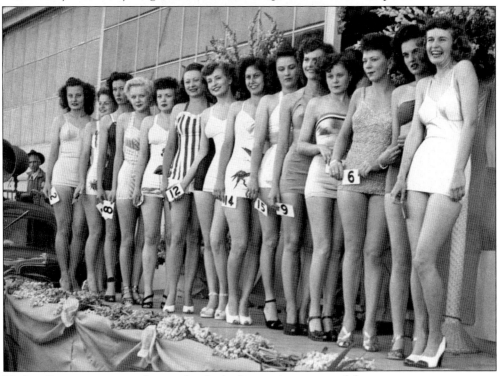
Harbor Queen contestants line up for the bathing suit segment of the pageant.

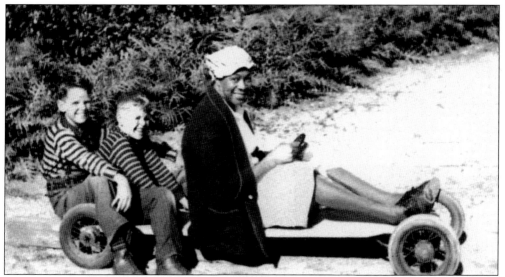

Lucy Hicks, known for her cooking and childcare for many of the prominent families of Oxnard, takes the lead on a go-cart in this 1940s photo. Chuck (left) and Dynes Donlon are the passengers.

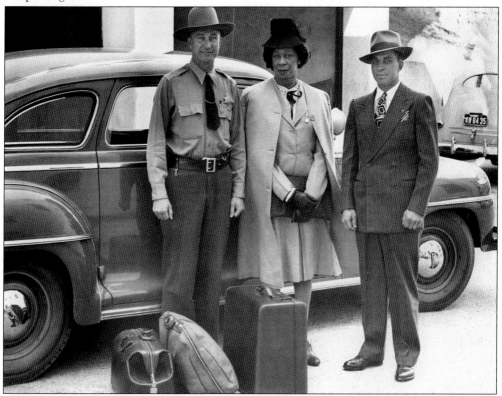

After a physical examination uncovered her secret, Lucy Hicks became known as the "madam who was a man." Because she perjured herself by claiming to be a woman, the married Lucy Hicks Anderson was sent to jail and banished from Oxnard for a 10-year period. She/he kept communication with many Oxnard friends but died alone in Los Angeles in the 1950s.

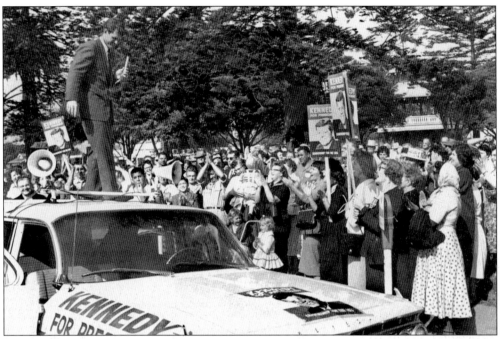

In 1960, Ted Kennedy made a stopover in Oxnard to campaign for his brother, John F. Kennedy.

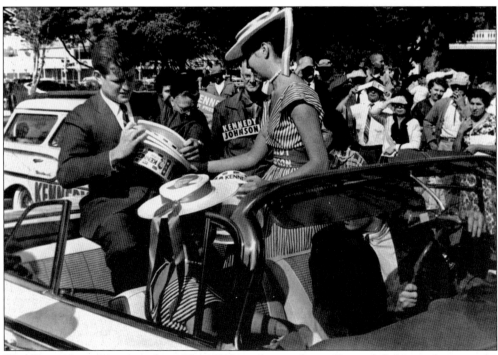

The Kennedy camp stopped at Plaza Park and passed out Kennedy/Johnson hats to the predominantly Catholic crowd.

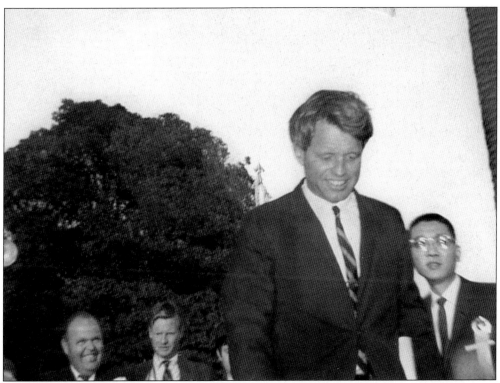

Robert Kennedy came to talk to Oxnard Democrats in 1968. Bobby Eck took a break from her job at the Carnegie building to take these pictures.

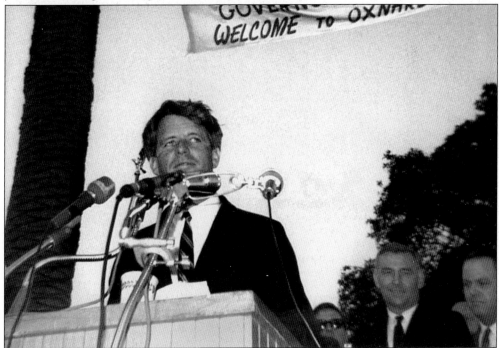

Kennedy's next stop was the Los Angeles Ambassador Hotel, where he was shot to death.

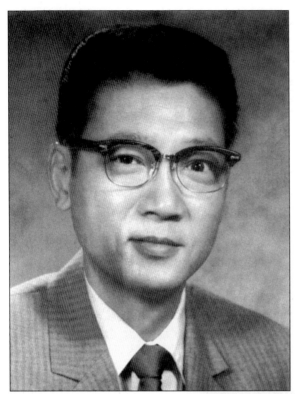

William D. Soo Hoo was at the Kennedy rally in 1968. Soo Hoo was the first Asian mayor in Southern California when he was elected in 1966. He served until 1970.

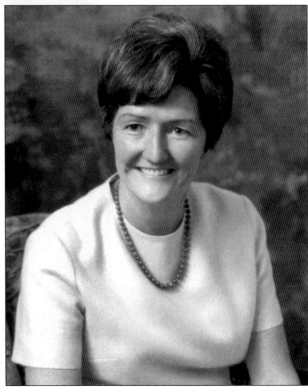

Oxnard's first female mayor, Jane Tolmach, was elected in 1973 and served for two years. Her husband, Al Tolmach, followed her tenure as mayor. Jane stayed active in the community beyond her public service years.

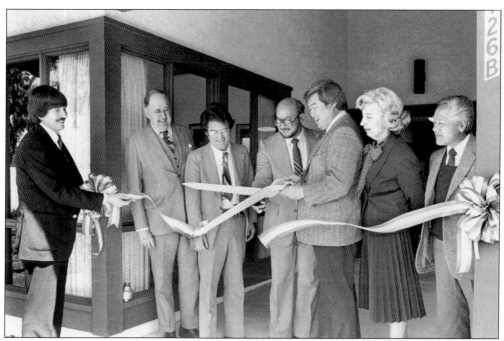

Oxnard dignitaries cut the ribbon for the new housing office in the Colonia neighborhood. Pictured, from left to right, are Bob Prescott, Blinn Maxwell, Manuel Lopez, a representative from the HUD office in Los Angeles, Tsugio Kato, Dorothy Maron, and Naouski Takasugi.

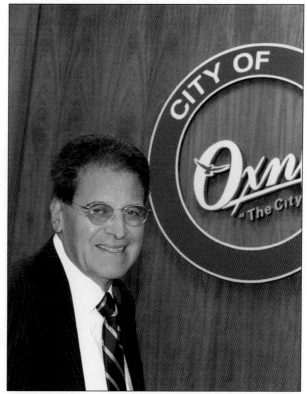

Dr. Manuel Lopez was elected mayor in 1992. He has the distinction of holding the office for the longest term—12 years. From 1903 to 2004, Oxnard has elected 26 mayors, including Richard Haydock, S.G. Bagnall, Joseph Sailer, H.H. Eastwood, E.G. Driffill, A.B. Westfield, E.R. Gill, Fred C. Snodgrass, W. Roy Guyer, Edwin Carty, A. Elliot Stoll, Rudolph Beck, Carl E. Ward, C.E. Davidson, R.F. Howlett, William D. Soo Hoo, Salvatore Sanchez Jr., R.H. "Bud" Roussey, Donald H. Miller, A.E. "Al" Jewell, Jane Tolmach, Al Tolmach, Dr. Tsujio Kato, Nao Takasugi, Lopez, and Thomas Holden.

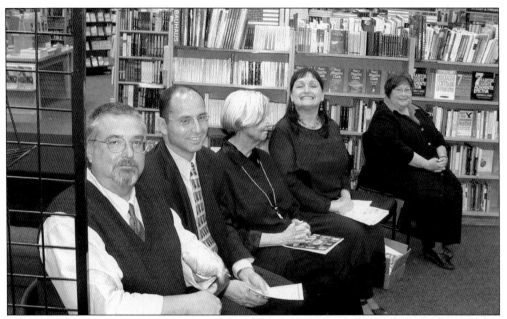

Pictured are several of the speakers for the unveiling of the *Oxnard Centennial Quarterly*, Vol. 47, Nos. 2 and 3, by the Ventura County Museum of History and Art. From left to right, they are Charles N. Johnson, Dr. Frank Barajas, Patricia Hoad, Jill Dolan, and Carol Bidwell. Not pictured is author Jeff Maulhardt, who was taking the picture.

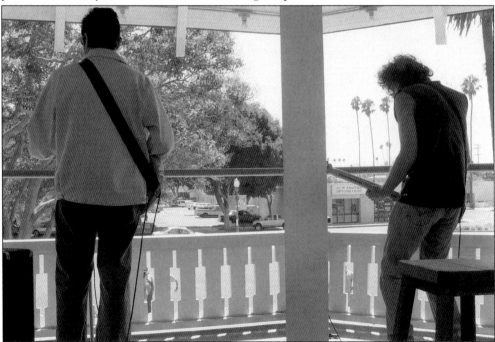

"Another Frank Barajas," on the left, accompanied by former Badfinger guitarist Glenn Sherba, serenaded a Saturday crowd with a mix of originals and Beatles-influenced tunes at a "Picnic at the Pagoda." The event was held inside the recently refurbished bandstand at Plaza Park, on August 30, 2003. (Courtesy of the author.)

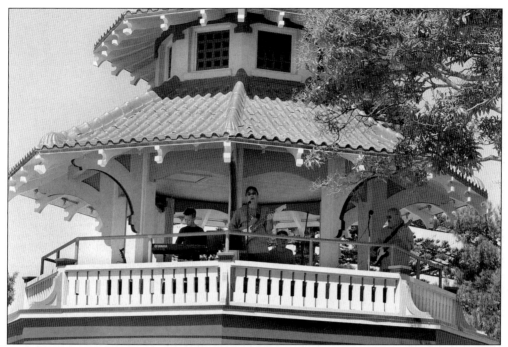

Mike Fishell and his son Roy, along with Steve White, offered an original take on the Beatles' "Strawberry Fields Forever," from inside the Pagoda.

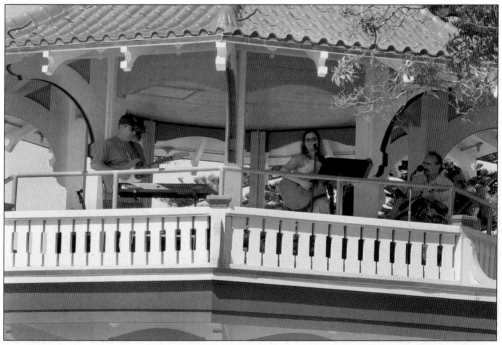

Lisa Henson became the third generation of Hensons to perform at the Pagoda bandstand, following in the musical footsteps of her grandfather Arthur Henson, who took the stage back in 1947. Joining Lisa for her set were John Welborn, Mike Fishell, Steve White, and Joel (the drummer).

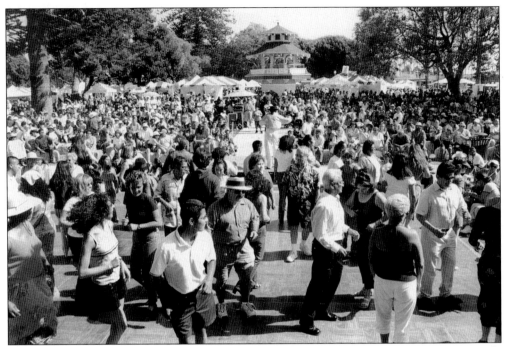

As Oxnard's population has expanded over the years, so have its events. Over 30,000 people crowd Plaza Park for the annual Salsa Festival.

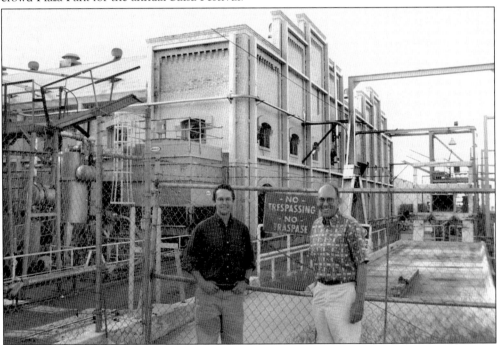

Though the Oxnard family never actually lived in Oxnard, their interest in the town, like their name, remains. Descendants of Ben Oxnard, Thornton Oxnard (left) and his father, Henry James Oxnard (right), took a guided tour of the old factory site. Here they pose in front of one of two remaining buildings. (Courtesy of the author.)

Six
Snow in Oxnard

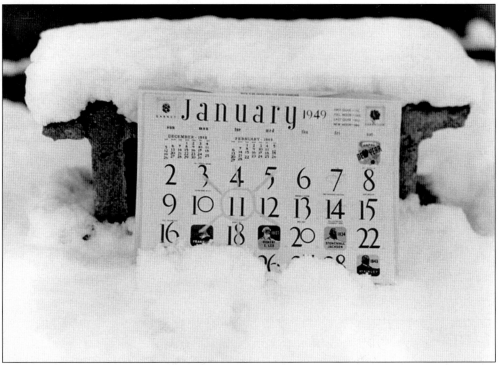

Bob Pfeiler had the foresight to place a calendar in the snow on January 11, 1949, to document the only time the residents of Oxnard were to wake up to a blanket of snow during the entire 20th century.

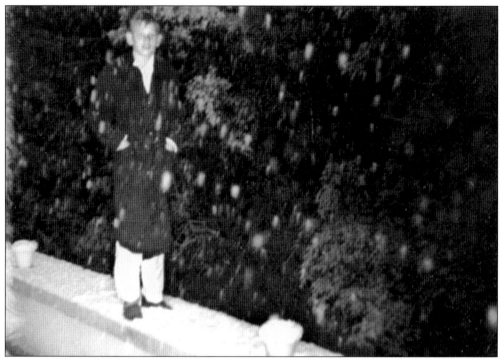
Bob Maulhardt took this picture of the snowstorm. His son Billy stands on a ledge at the Maulhardt ranch.

Emil Pfeiler had the foresight and the equipment to capture the rare occasion on film. By the next morning, all of the film in Oxnard had been purchased.

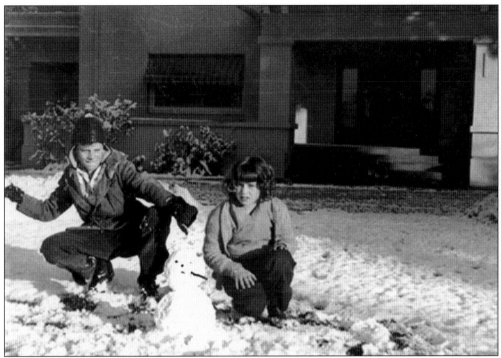

Marilyn helps her brother Billy build a snowman, only to have Billy use it for target practice.

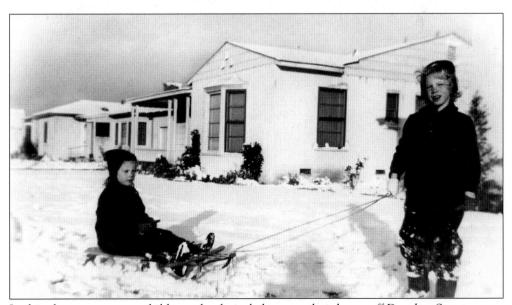

In this photo, two young children take their sleds out at their home off Douglass Street.

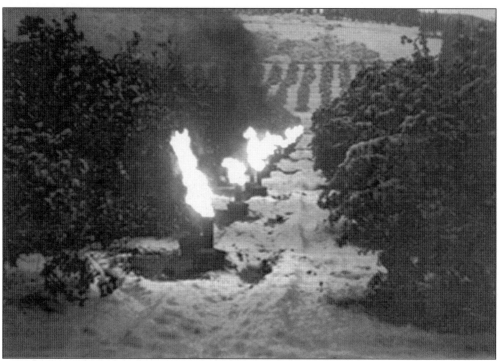
Smudge pots burned throughout the county in an effort by the farmers to save their citrus crop.

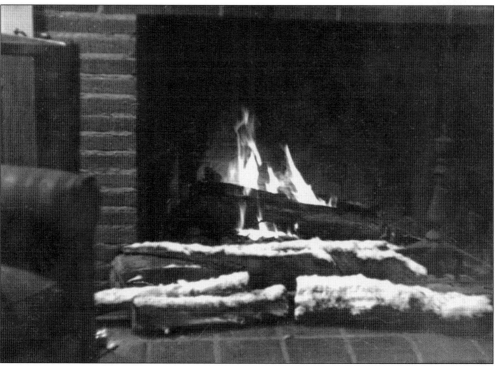
Fireplaces competed with smudge pots to keep things warm.

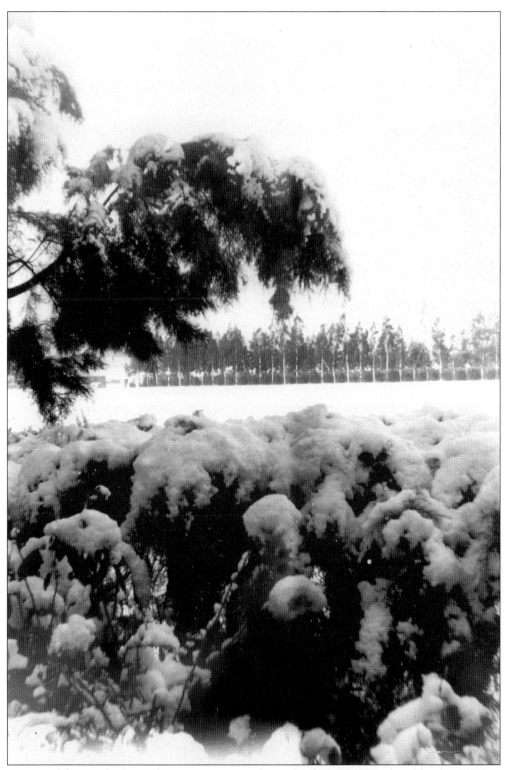
A view of the Friedrich ranch at Rose Avenue shows the deep snow produced by the storm.

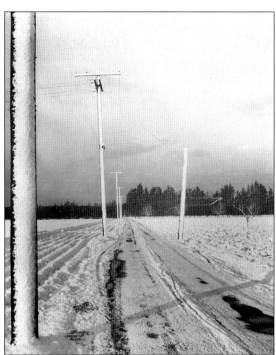

Roads and telephone poles were blanketed in snow for the only time in the city's existence.

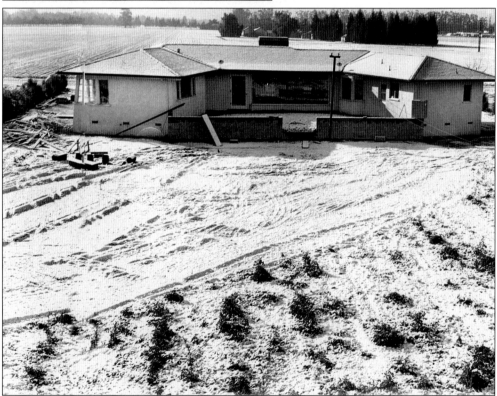

In this view from Bob Pfeiler's ranch, near present-day Cesar Chavez Boulevard, the city of Oxnard is visible in the distance.

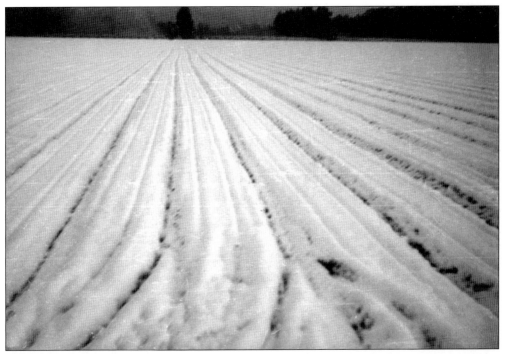
Row crops suffered more than the citrus crop.

Orchards without smudge pots had to cut the tree branches back and wait for the next season for new growth.

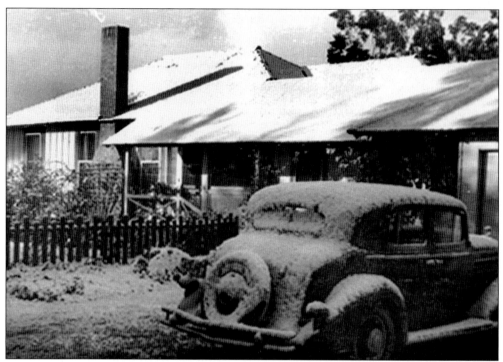
Here is a view of the Bell Ranch near present-day Rice Road and Camino Del Sol.

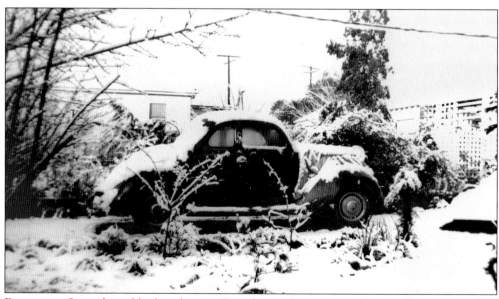
Downtown Oxnard was blanketed as much as the rural areas, as evident in this picture taken from D Street.

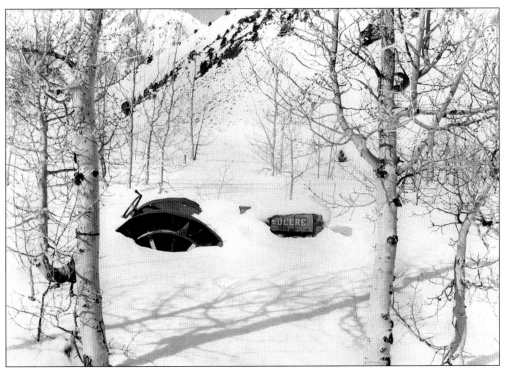
Some of the foothills outside of the Oxnard area were hit by three feet of snow.

This cat's prey was tougher to catch after the abnormal weather.

105

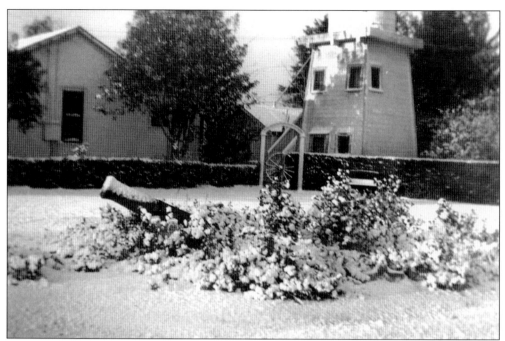

This view of the John Donlon ranch in El Rio shows a snow-covered cannon that is believed to have belonged to John C. Fremont's troops from when he passed through the area in 1847. The cannon had been unearthed when ground near the river bottom was plowed.

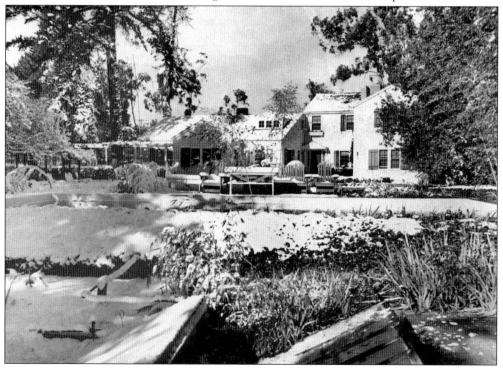

Thomas Bard built the Bard manor house in 1912, and by 1949 it was serving as the officer's club for the construction battalion.

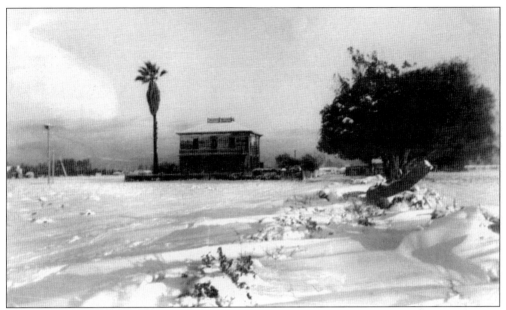

The Cloyne ranch was located north of Channel Island Boulevard and east of Saviers Road.

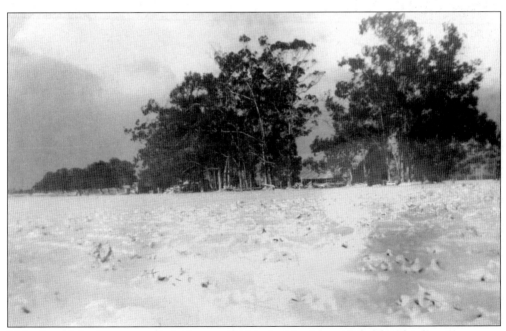

This view of the Cloyne ranch looks east. Today the Harrington School and a shopping center occupy the land.

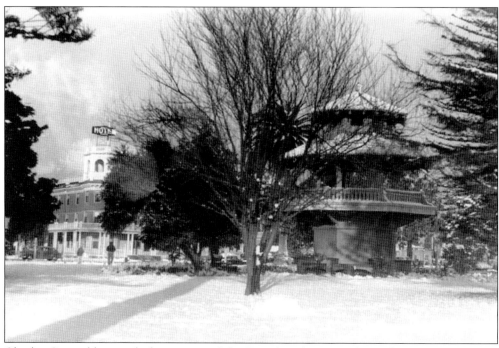

Charles Covarubbias took this picture of the Pagoda. The Oxnard Hotel can be seen in the background.

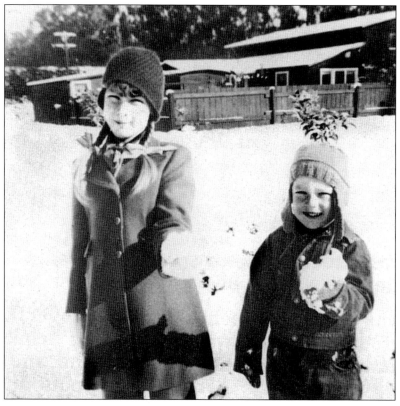

Mary Lee and Roby Naumann display their snowballs.

Seven
SPORTS

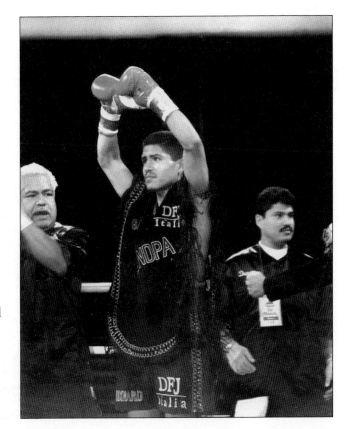

Roberto Garcia won his first 32 professional fights before finally losing the International Boxing Federation Super Featherweight crown to an undefeated Diego Corrales. Pictured in the ring, from left to right, are Roberto's trainer and father, Eduardo; Roberto; and his brother.

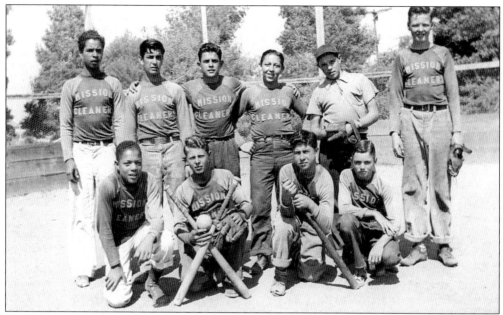

The Mission Linen baseball team won the 1940 Junior City League championship with an undefeated record. Pictured, from left to right, are (front row) Herman Spurlock, Lee Lockwood, Henry Martinez, and Bobby Burfeindt; (back row) Louie Olquin, Jim Nichols, Albert Valencia, Eddie Weigel, Bill Everetts, and Hank Askren.

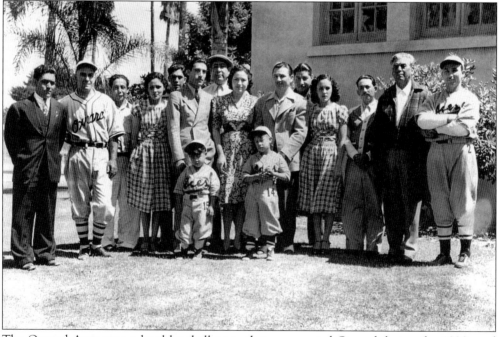

The Oxnard Aces were a local baseball team that represented Oxnard during the 1930s and 1940s. The team had a president and other officers and played weekly games at the original Haydock School, the site of the 1913 big league game between the Giants and White Sox and currently the site of Driffill School at Ninth and C Streets.

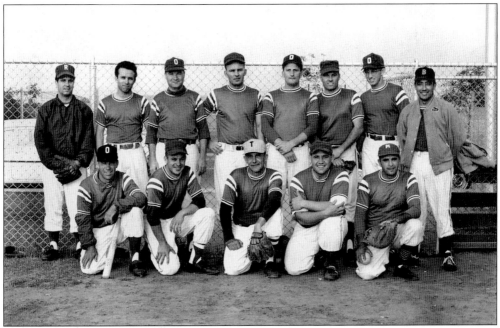

The Oxnard Merchants evolved from the Oxnard Elks and from the original Blackwell Drugs team. The Merchants won third place in the nationals for fast-pitch softball in Clearwater, Florida. Pictured c. 1963, from left to right, are (front row) Bill Stovall, Chuck Stovall, Ted Marienthal, Pat Weigel, and Gabe Olivas; (back row) Louie Yaparragary, Bob Stovall, Dewayne Jones, Virgil Willard, Jerry Willard Sr., Wayne Workman, Jim Daniels, and Ray Martinez.

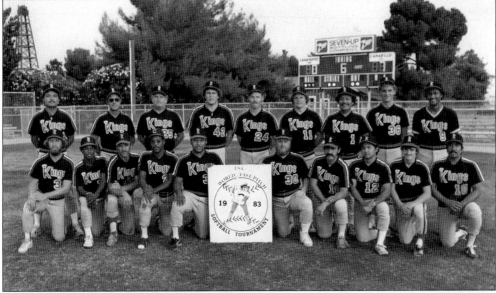

The Oxnard Merchants went on to become the D.J. Candy Kings when DeeWayne Jones took over the team in 1965. The team won the regional title in 1967 under the pitching dominance of Jackie Newman. As the pitching coach for the Camarillo Kings, Newman helped guide the Kings to a world championship in 1981.

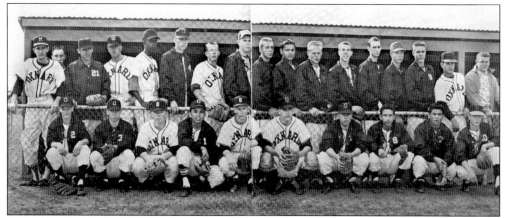

Pictured is the 1958 Oxnard High School baseball team. From left to right, they are (front row) Eddie Wall, Wayne Sewell, Clarence Wood, Bob Zuniga, Terry Tackett, Phil Lloyd, Jack Ross, Ben Diaz, Richard Andres, and Pat Dalton; (back row) Mike Machesto, Bill Houch, Ernie Carrasco, Denny Lemaster, Franklin Gilbert, Jim Isom, Frode Miller, Ken McMullen, Bob Steele, Richard Ramirez, Darryl Harris, Ben Assumia, Russell Hayes, Jerry Newman, Dave Meloria, Richard Velasquez, and John Campbell.

After a successful baseball career that took him through the 1977 season, Oxnard High graduate Ken McMullen returned to Ventura County to run the family business. McMullen's big league career included 156 home runs and a seven-year stretch in which he averaged 17 home runs per year. Oxnard High teammate Denny Lemaster chalked up 90 career victories in the majors, including 17 wins in 1964 for the Milwaulkee Braves. Another Yellowjacket teammate, Terry Tackett, stayed local and became a successful baseball coach and principal.

The 1972 Sunset Little senior all stars became national champs and world runners-up. The team included, from left to right, (front row) Daryl Samuel, Jim Lapoint, Frank Rodriguez, Albert Givens (batboy) Tom Barber, and Alan Pinedo; (back row) Craig Yonker, Walt Moody, Victor Brown, David Escobar, George Hill, Sterling Bruner, Frank Gutierrez, and Mike Olivera.

The 1978 Port Hueneme big league team was composed of boys from both Hueneme and Oxnard. The boys won the California Division Three championship and went on to the Big League World Series in Florida. Pictured, from left to right, are (front row) Doug Eaken, Robbie Duran, Dennis Dan, Doug Rogers, Gilbert Infante, Ray Gallardo, and Jerry Willard Jr.; (back row) coach Jerry White, Johnson Wood, Jeff Barks, Jere Longenecker, Augie Avila, Ernie Carrasco, Jon Larson, Roger Frash, and coach Jerry Willard Sr.

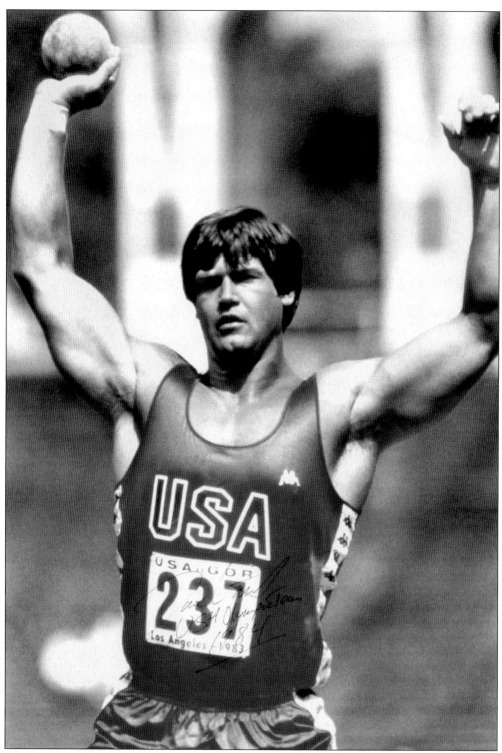
Dave Laut, a graduate of Santa Clara High School, won the bronze medal in the shot put at the 1984 Olympics in Los Angeles with a distance of 20.97 meters.

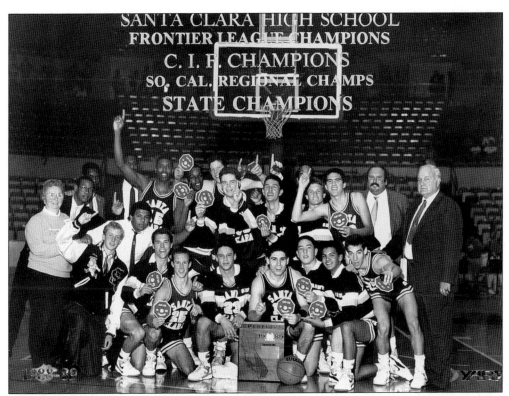

California Sports Hall of Fame coach Lou Cvjanovich guided the 1988–1989 Santa Clara basketball team to beat Santa Rosa's Cardinal Newman High.

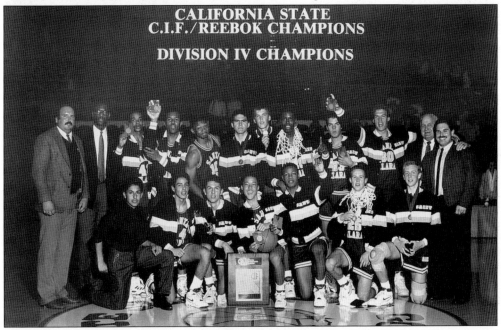

The 1989–1990 Santa Clara team featured future UCLA player Shon Tarver and completed back-to-back championships by beating Vanden, Fairfield.

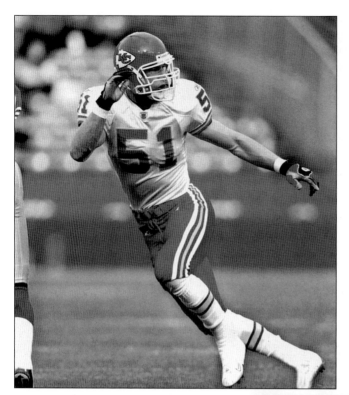

Scott Fujita, graduate of Rio Mesa High School, was drafted by the Kansas City Chiefs and was immediately playing as a linebacker. The 6 foot, 5 inch, 250-pound Fujita was a walk-on at the University of California at Berkeley. Fujita was recommended by former coach Brian Husted and went on to earn a scholarship. Scott was a fifth-round draft choice by the Chiefs in 2002. By 2003, he led the team in tackles.

Hueneme High and USC all-time leading pass receiver Keary Colbert was drafted in the second round of the 2004 NFL draft by the Carolina Panthers as a wide receiver. The 5 foot, 10 inch, 193-pound Colbert caught 207 passes during his tenure at USC for a total of 2,964 career receiving yards. The report on Colbert by NFL scouts was that he was a "good worker on and off the field, willing to do the little things necessary to succeed."

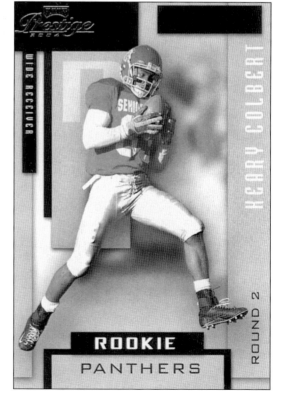

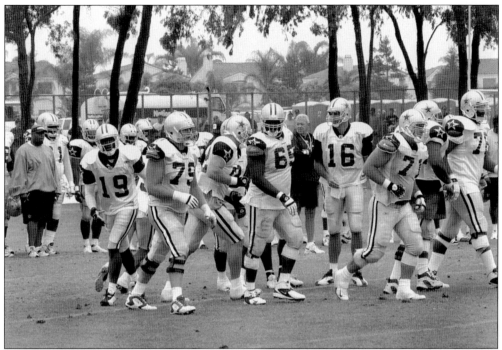

In 2004, the Dallas Cowboys drafted Oxnard High and USC graduate Jacob Rogers (No. 79) as an offensive tackle in the second round, 20th pick. (Courtesy of the author.)

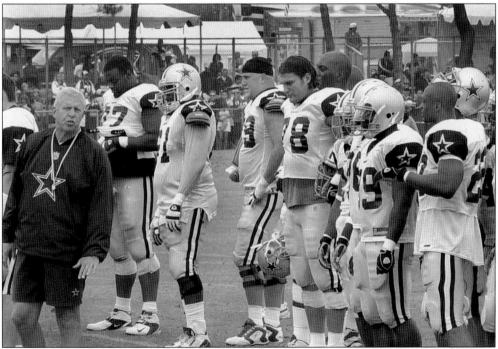

Rogers was fortunate to have his new team practice in Oxnard for his first season in the pros. Coach Bill Parcells (left) took notice of his 6 foot, 6 inch rookie by giving Rogers plenty of "snaps" during the early scrimmages.

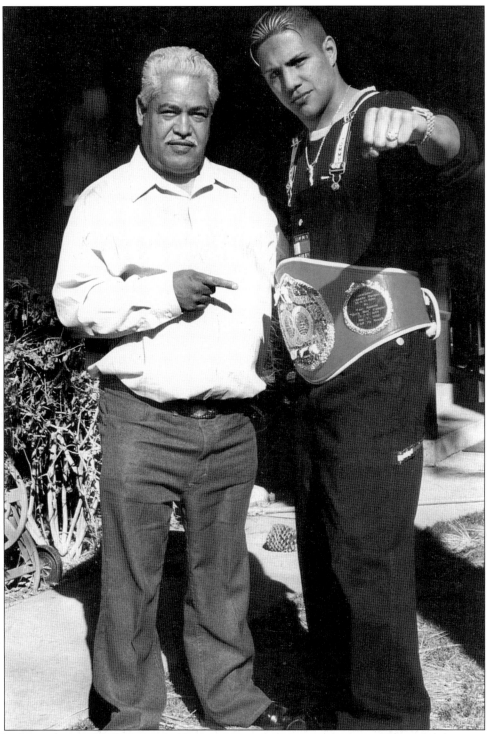

On December 12, 1998, Fernando Vargas became the youngest junior middleweight champion in boxing history at the age of 21 years and 5 days old. Vargas poses in his championship belt with his trainer and close family friend, Eduardo Garcia.

Eight
THE CENTENNIAL

On June 29, 2002, one year prior to the centennial celebration of the city, a kickoff event at Plaza Park featured guest speakers and a six-layer cake.

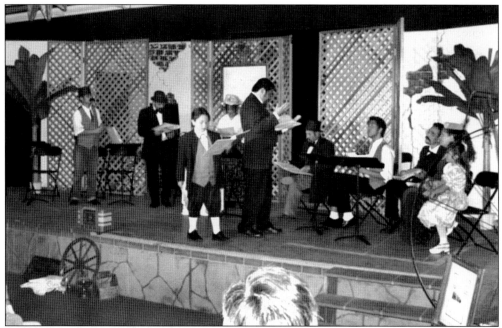

The play *Sugar Town* was written and directed by Javier Gomez. It ran for several weeks during the centennial countdown weeks.

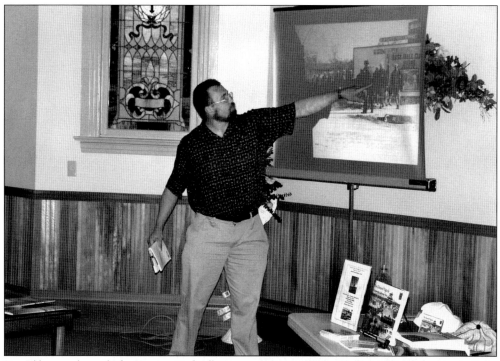

Jim Elfers, author of *The Tour to End All Tours*, was part of a baseball weekend that included a slide show at Heritage Square, followed by a play by at Pacifica High Performing Arts Center, and concluding with the reenactment of the 1913 Giants/White Sox game at Oxnard College Condor Field.

Frank Boross and Chris Higgins designed the posters of many of the centennial events, including the reenactment game on June 29. Based on the book *The Day the New York Giants Came to Oxnard*, the event featured a barbecue and a horse race in the seventh inning, true to the 1913 event.

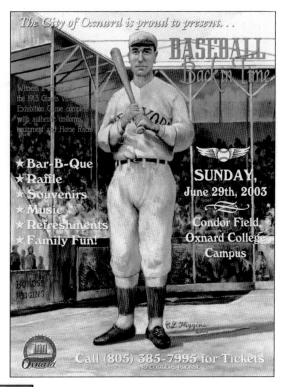

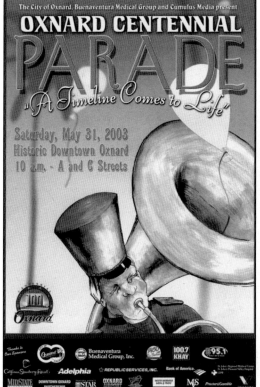

Boross and Higgins's first poster was for the centennial parade, held on May 31, 2003. The parade featured 10 floats sponsored by the City, which represented the 10 decades of cityhood.

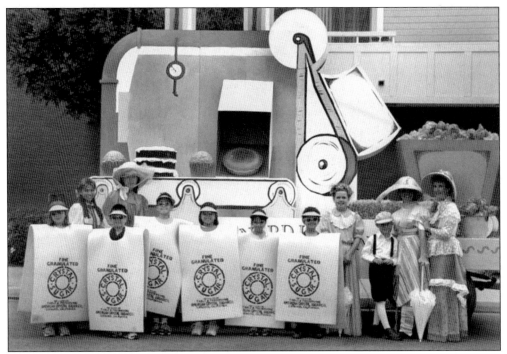
The second-grade students at McAullife School performed as the "Dancing Sugar Beets" at the centennial parade.

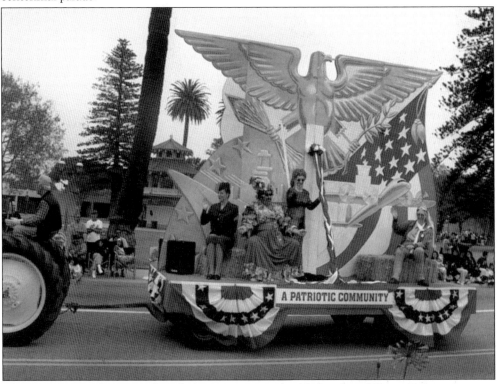
The city of Oxnard sponsored 10 floats representing the 10 decades of the city's history.

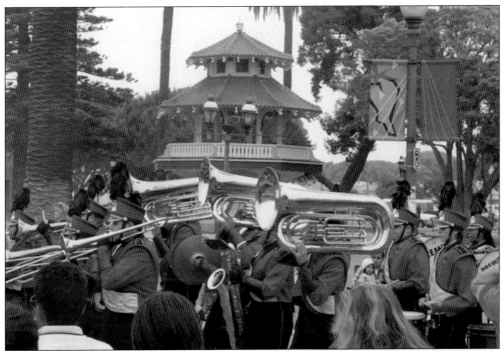

All five high schools sent marching bands to participated in the centennial parade. (Courtesy of the author.)

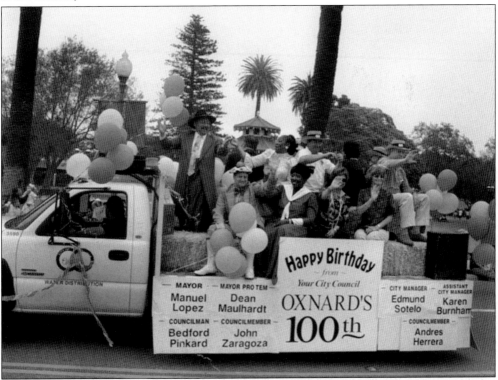

Councilman Bedford Pickard, in a zoot suit, encourages the crowd to join in on the fun.

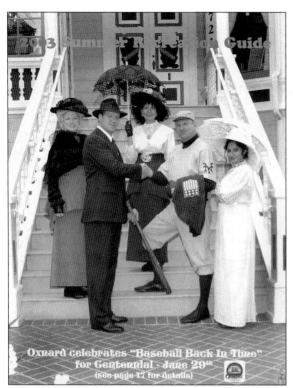

The 2003 Summer Recreation Guide for the City of Oxnard featured several "Baseball Back in Time" participants. Pictured, from left to right, are Holly Gene Leffler, Jeff Maulhardt, Connie Korenstein, Eddie Frierson, and Claudia Garcia.

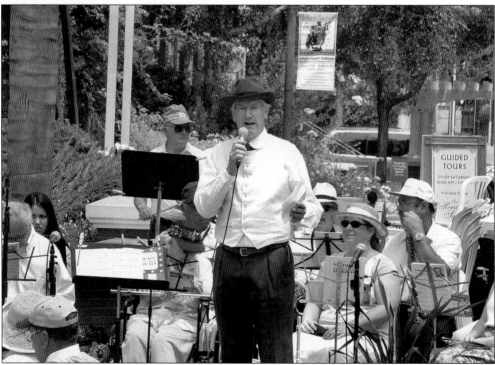

Spencer Garrett, grandson of original New York Giants ballplayer Fred Snodgrass, shared a few stories at the Heritage Square barbecue before the reenactment game.

The steering committee and the Knights of Columbus hosted a pre-game barbecue. (Courtesy of the author.)

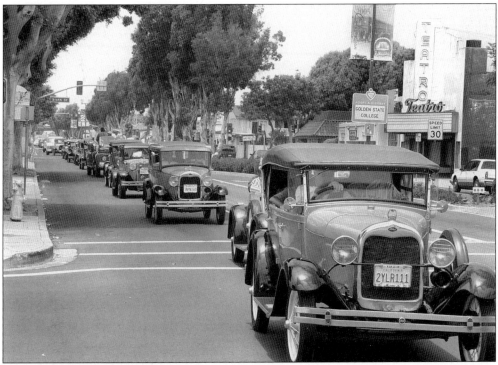

The players for the reenactment game were transported from Heritage Square to Condor Field courtesy of the Model-T Club. (Courtesy of the author.)

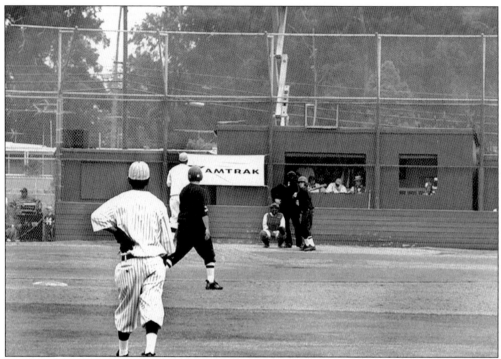

The reenactment game featured recently graduated high school players who used replica gloves, bats, and uniforms. This time, it was the White Sox who won the game, beating the Giants 9-4. (Courtesy of the author.)

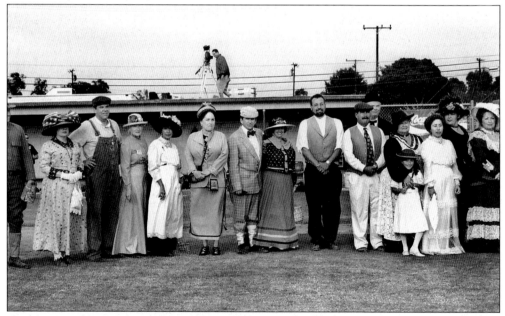

At the original game, the players and boosters lined the field for a memorable picture. With so many fans attending the reenactment game, this photo op was expanded to anyone who came in period clothing. The chairman of the baseball centennial committee was Gil Ramirez, standing seventh from the right, wearing white pants. (Courtesy of Debbie Maulhardt.)

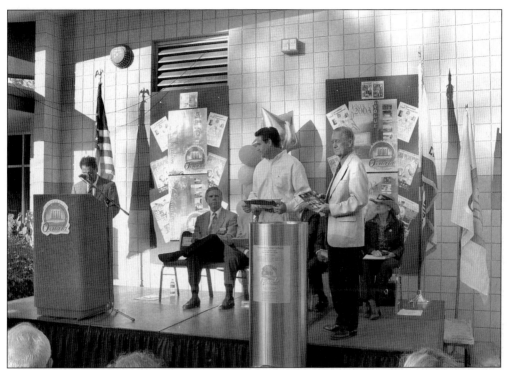

In this photo, Gary Blum takes the stage to add something to the time capsule, which is located at the Oxnard Public Library and will not be opened until 2053. Pictured, from left to right, are Mayor Lopez, councilman Dean Maulhardt, Gary Blum, Ed Roebings, and Grace Hoffman.

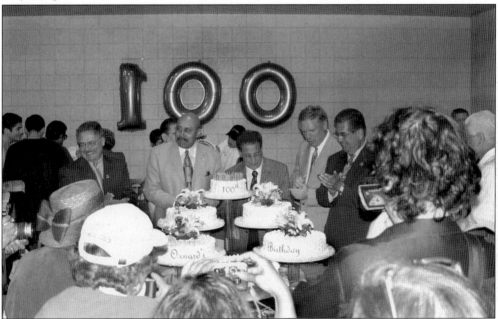

On June 30, 2003, the City Fathers capped off the final centennial event with the lighting of the city's birthday cake. Pictured, from left to right, are city manager Ed Sotelo, councilman Bedford Pinkard, Mayor Lopez, councilman Dean Maulhardt, and councilman John Zaragosa.

BIBLIOGRAPHY

I used a variety of sources in putting together this publication; however, my choices were limited to the information and pictures available and archived at area libraries. I have tried to supplement those resources by tracking down the owners of private collections and by keeping my eyes and ears open. To those readers who feel that some aspects of Oxnard's history have been under represented here, this is a call to do something about that and to share the resources you may have. Anyone interested in sharing their pictures or stories with me may contact me at my website at www.jeffmaulhardt.com, or by email jeffmohart@aol.com, or I'm "in the book."

A Comprehensive Story of Ventura County, California. Oxnard: M&N Printing, 1979.

Agricultural Life 1, no. 1 (March 1957). (Courtesy of Sam Camacho.)

An Unofficial Guide to Naval Construction Battalion Center Port Hueneme. Lubbock, TX: Boone Publications, Inc., 1970.

City of Geraniums. Oxnard: Oxnard Chamber of Commerce, 1958.

Donlon, Bert. *The Donlon Family 1750–2002: A Family History.* Self-published.

Gold Coast News, Eighth Year, no. 20, July 1, 1971.

Oxnard Telephone Directory. Oxnard Telephone Company, September 1941.

Smalley, Jack. *The Star-Spangled Story of the Channel Islands.* Oxnard: Alexander Lithograph Co., 1976.

Soto, Camille. "Mayors of Oxnard." *The Oxnard Centennial Press,* June 30, 2003. Robert J. Frank Intermediate School.

The Oxnard Daily Courier. Microfilmed at the Oxnard Public Library and at the library at the Ventura County Museum of History and Art.